Watercolour
Textures

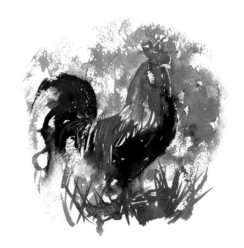

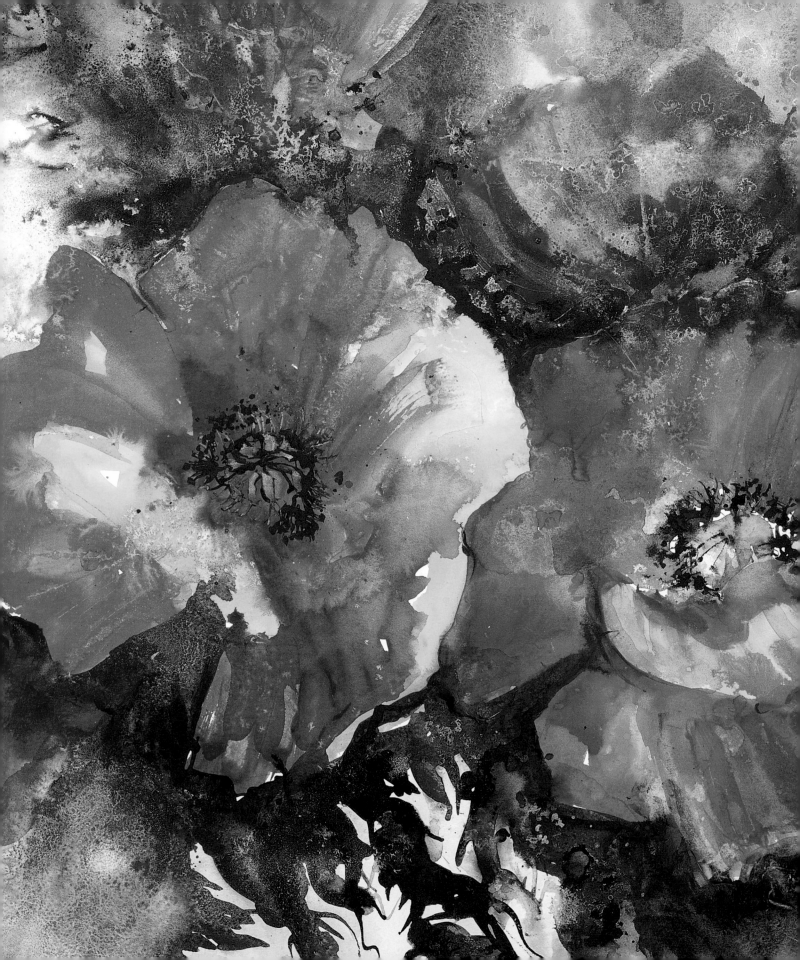

Collins · *artist's studio*

Ann Blockley

Watercolour Textures

First published in 2007 by
Collins, an imprint of
HarperCollins*Publishers*
77-85 Fulham Palace Road
Hammersmith, London W6 8JB

www.collins.co.uk

11 10 09 08
6 5 4

A catalogue record for this book is available from the British Library

Editor: Diana Vowles
Designer: Kathryn Gammon
Photographer: Howard Gimber

ISBN 978 0 00 721385 6

Colour reproduction by Colourscan, Singapore
Printed and bound by Printing Express, Hong Kong

Acknowledgements

I would like to thank all the team who have helped me to put
this book together and particularly Caroline Churton for her
great support throughout the project. I am especially grateful
to Moira Huntly and Shirley Trevena for allowing me to
include their paintings.

page 2: Poppies, 96 × 80 cm ($37\frac{1}{4}$ × $31\frac{1}{2}$ in)

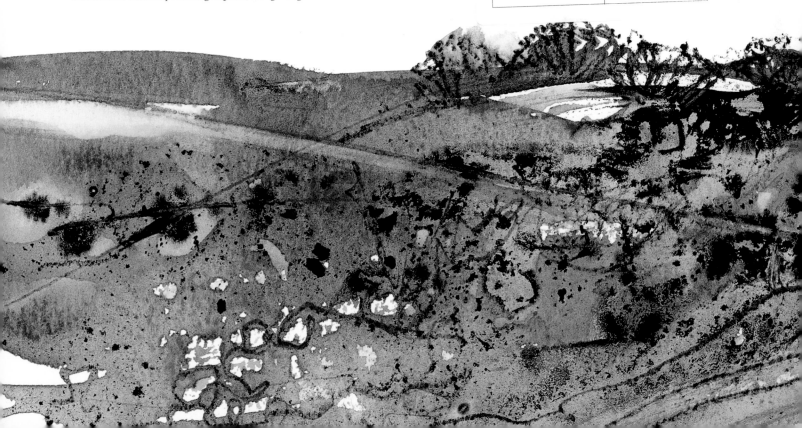

Contents

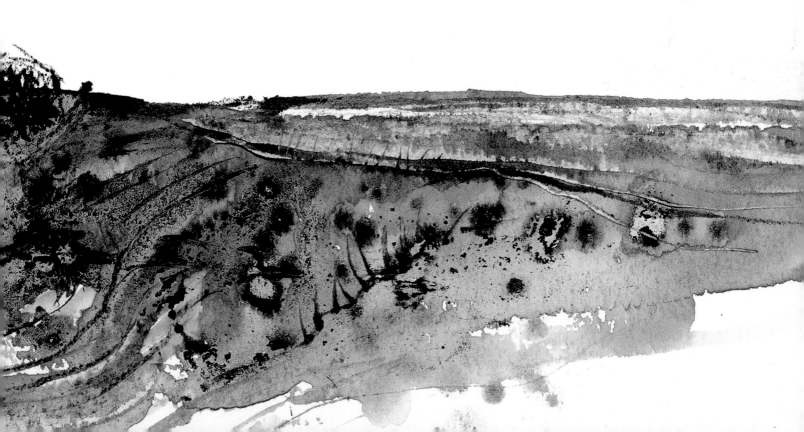

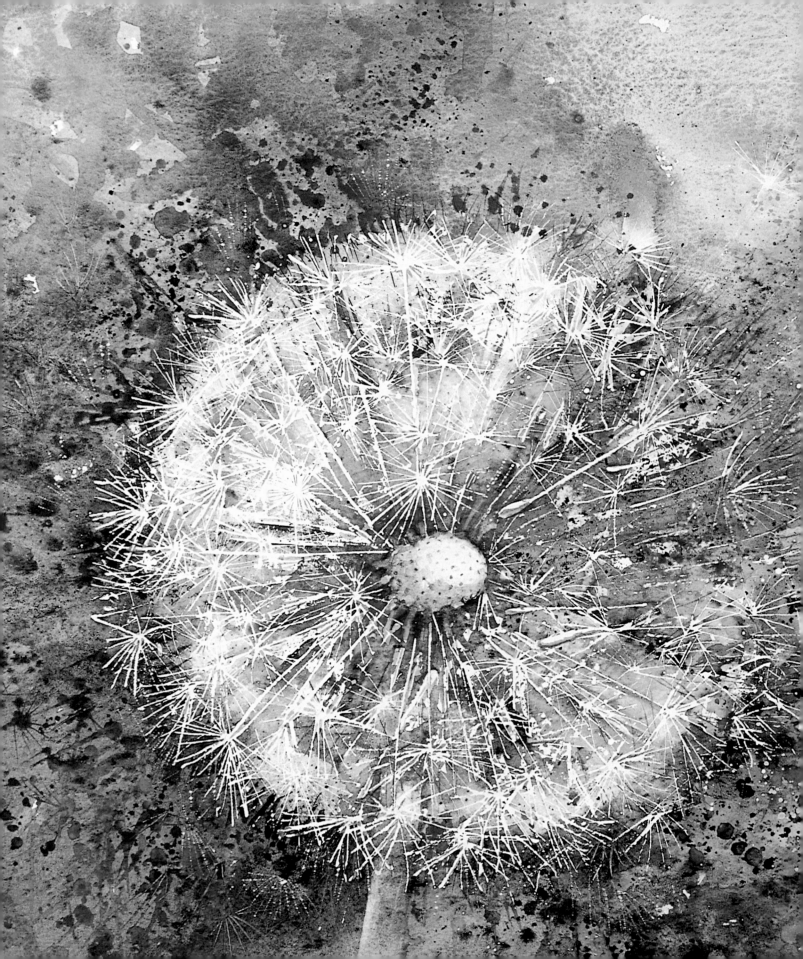

Introduction

Watercolour is most often regarded as a medium used to create delicate, translucent pictures rather than one capable of vigour and dense textures. However, taking such a narrow view of it is to overlook the immense range of expression it offers to the artist who is prepared to explore and experiment, testing the limits of what can be done with it when it is handled with an open mind and a spirit of creativity.

It is the aim of this book to encourage you to discover a textural approach to painting in watercolour, both employing it alone and combining it with other mediums, and even materials too – collages are not beyond the province of the watercolour painting. Indeed, my hope is to encourage you to see watercolour as a medium without boundaries, and one which is superb for the creation of paintings that are rich in texture and interest.

◁ Dandelion Clock
37 × 52 cm (14¹/₂ × 20¹/₂ in)

△ Ann in the garden of her house in the Cotswolds, where she lives and paints.

About this book

This book is designed for artists who have some experience of traditional watercolour methods but would like to explore further and stretch the possibilities of this versatile medium beyond its normal boundaries. The emphasis is on creating textures by manipulating paint to build a wide variety of textural effects and by also using acrylic, gouache, inks and other materials, both on paper and other surfaces. It is a book for those who want to learn how to experiment and play with paint.

However, the book is concerned not only with practical techniques but also with the thought processes involved in the development of a painting. Before one can paint in a truly creative and liberated manner a certain painterly way of viewing the world needs to be learnt. The looking and thinking are as important as the painting itself. Throughout the book I have emphasized this concept and given you some suggestions as to how you can develop your own ways of seeing.

△ Orchid
41 × 33 cm (16 × 13 in)

This orchid was painted much larger than life. I tried to treat the flower as a series of abstract shapes, allowing speckled texture to flow within each area.

I am delighted to be including the work of guest artists John Blockley, Moira Huntly and Shirley Trevena to give you examples of work in a different style from my own. I hope the following chapters will encourage you to practise and explore textures and subjects, thereby developing your own individual painting style.

Throughout the book you will also find a number of practical features:
- **Explore Further** exercises to encourage you to take action and build your confidence
- **Studio Tips** to aid your painting
- **Projects** to help you put the thinking into practice
- **Demonstrations** of paintings shown stage by stage to show you the development of a painting.

Taking risks

The title of the book is *Watercolour Textures*, but there is a subplot to what this title suggests. The undercurrent theme relates to overcoming the fears that artists experience and to breaking away from the familiar and comfortable. In order to make progress as a painter I believe one has also to develop as a person. The decision to stay still, as an artist as in life, should be due to considered choice and not to fear of change. A change of direction can be scary but may also turn out to be hugely fulfilling and fun.

For me, the development of this book has been a turning point in my painting career which has taken me on a voyage of self-discovery. I have been known as a flower painter for many years. I love flowers and do not get tired of painting similar subjects repeatedly; each time feels like a fresh exploration with something new to be said. However, I had reached a point where there was an element of being so comfortable with my ways of working that the challenges and the rush of adrenalin that come with them were sometimes reduced.

To break out of this territory into new subjects, mediums and techniques has been terrifying. Like most of us, I have a fear of failure and it would have been easier to stick to what I have found success with. In spite of this, I found it increasingly difficult to ignore the many other subjects that attracted me and that I itched to try to paint – pantile rooftops and crumbling stonework in Italian villages, stormy skies in Wales, textiles in Peru, mountains in Tunisia and many scenes in everyday life, such as the twisted branches of a hawthorn tree, a church on a hilltop and the patterned china in a friend's dresser. Every time something new struck a visual chord I would think how I might try to paint it if ever I got time.

After a while, this became a habit. I felt encouraged when I realized that my interest in many of these new subjects related to particular criteria that were already being explored in my flower pictures. I was not interested in the botanical detail of the flowers – it was their shapes, patterns, marks, tones and colours that I painted and the new subjects were also made up of similar abstract qualities.

In flower painting, the subject was the bit that gave the painting a focus but it was the backgrounds that I had the deepest interest in. Here I could let the paint flow and create loose impressions without restriction. My fascination lay in the manipulation of the paint and resulting textures. I looked at the backgrounds of my flower paintings and realized that within them, inside my lovely, familiar comfort zone, there were the textures and marks that made up landscapes, buildings and whole worlds. I had finally run out of excuses for not moving forward, and realized that I had at least to venture into the world beyond the garden in order to explore.

▽ Honesty
29 × 30 cm (11½ × 11¾ in)

The honesty seedheads are simply a series of flat oval shapes. I concentrated on the textures of the background, using Indian ink to help granulate the watercolour pigment.

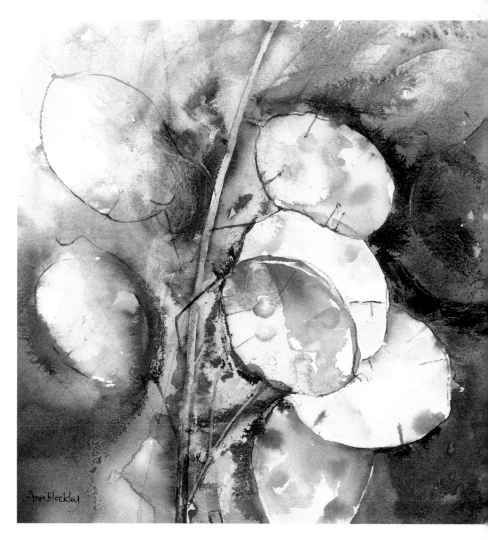

Landscapes and beyond

I can pinpoint the first time that I realized what an endless source of amazement landscape painting could be. I was on the Yorkshire moors watching the clouds race past. As they did so, the land beneath was continually changing in kaleidoscopic fashion, the shadows and sunlight seeming to redesign its contours and textures. It was like watching a play; first the sky was dark and the hills pale, then suddenly, on the flick of a switch, all was reversed.

This experience reminded me of the many times, as a child, that I climbed mountains with my mother while my father painted them. I loved to watch these hills disappear and reappear in front of me as if by magic as clouds came and went. I remembered the distant rain that seemed to melt the hill tops and the shafts of light slicing through. I realized that although I had always deliberately avoided the idea, these were subjects that I felt a deep connection with and wanted to paint.

I felt completely overawed by the immensity of the challenge. It has always seemed a hopeless ambition for me to even try to capture such scenes on paper when my father, John Blockley, was so well known for his inspired painting of these subjects.

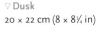
▽ **Dusk**
20 × 22 cm (8 × 8¾ in)

I used clingfilm to create the streaky sky and coloured pencil to draw the smudgy trees.

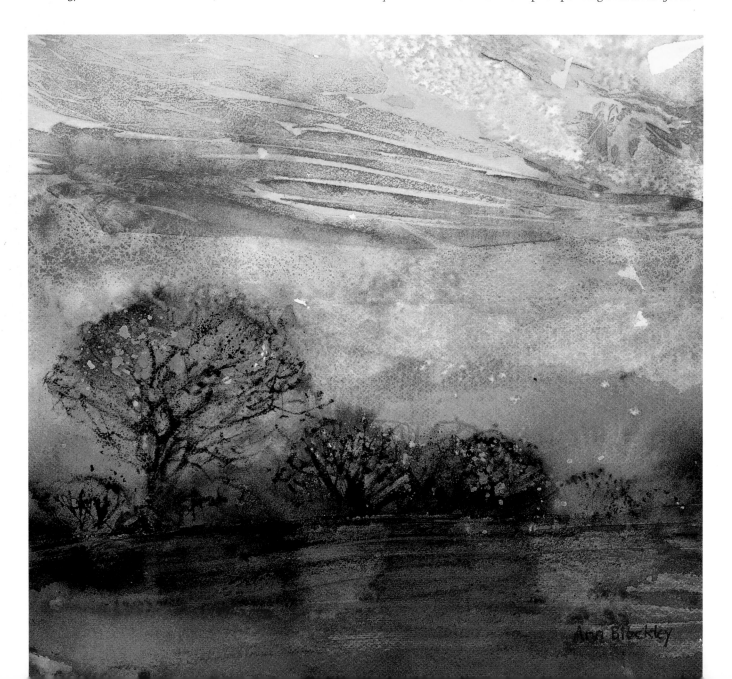

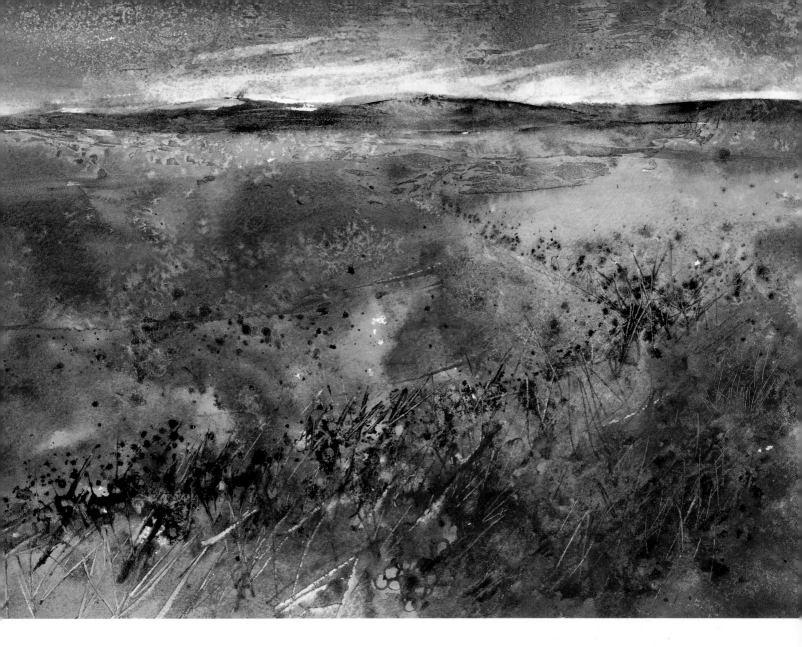

Breaking new ground

However, I still felt in some way impelled to have a go and take the risk. I had not planned to do this publicly in the form of a book, but that is the way it has turned out! The following pages show you some of my paintings, not only of landscapes but buildings, flowers, animals and still lifes.

A finished book may appear effortless to the reader. It does not reveal the frustrations and vulnerability that go behind its development. These are emotions that I believe most creative people feel and are a part of the painting process. I hope that my book will give you plenty of ideas but also encourage you to challenge yourself and take some risks of your own.

△ **Imagine**
27 × 39 cm (10½ × 15¼ in)

This painting was developed from my imagination. I wanted it to suggest a landscape without being too specific. The textures are similar to those used in the background of some of my flower paintings.

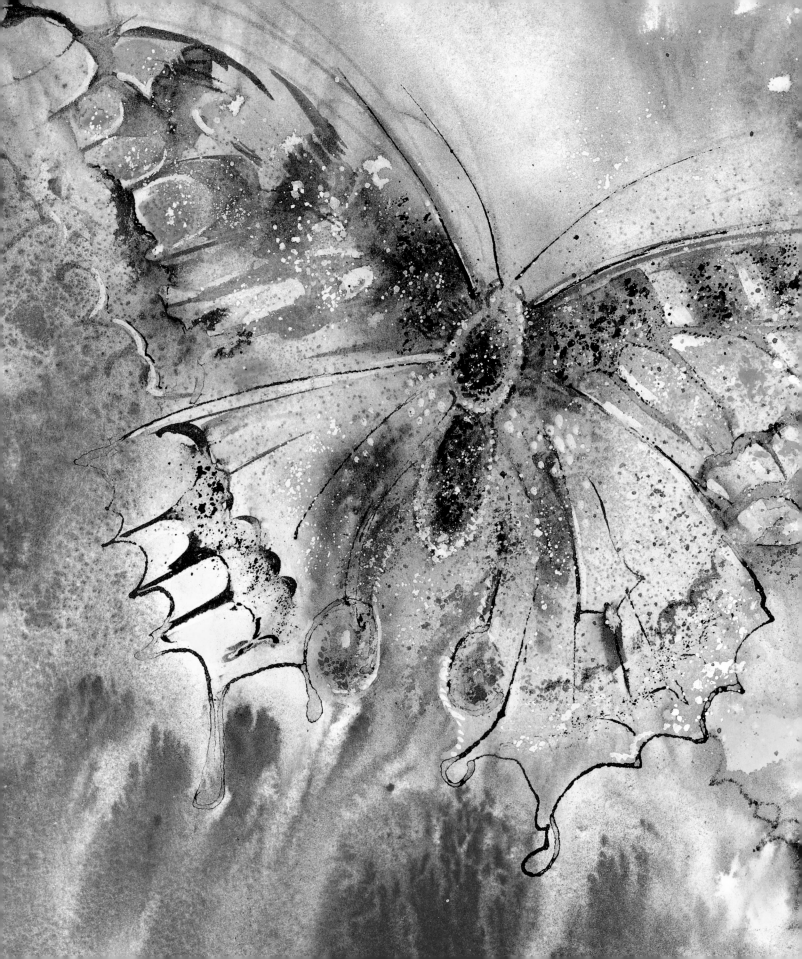

Manipulating the paint

While watercolour tends to be mainly associated in people's minds with smooth, translucent washes, it can be used to create a surprisingly wide variety of textures. The ideas you will find in this chapter often depart from conventional methods, though they all use a base of traditional watercolour paint from tubes, diluted and applied to watercolour paper.

In the next few pages we will be looking at how washes can be manipulated, added to, broken up and played with in order to build fascinating textures, and how standard brushwork can be supplemented with other mark-making ideas. All these techniques can be used to represent both subjects and backgrounds in stimulating and exciting ways that transform the appearance of a watercolour painting.

◁ Butterfly Textures
20 × 29 cm (8 × 11½ in)

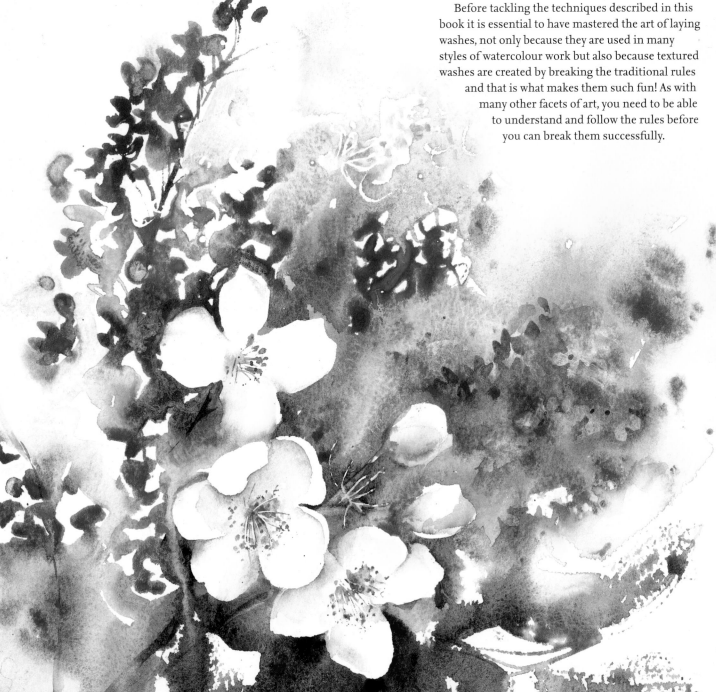

▽ Blossom
28 × 29 cm (11 × 11½ in)

The background combines wet-into-wet washes of blended colour with different types of brushwork. I dabbed on the petals to build small, curvy marks and swept the leaves loosely over the tooth of the paper to create a sketchy, broken texture.

Laying washes

In this book the term 'wash' is applied loosely to include any area of a painting, whether it be a background or within a specific shape. A wash is the basic building block of watercolour painting, and the traditional method of laying a wash is to load a brush with diluted paint and apply it to the paper, allowing each brushstroke to overlap and blend with the previous one.

To achieve rich but softly graded areas you need to mix the paint to a certain consistency, which could be described as 'creamy milk'. You require enough pigment to give strength of colour and enough water to let the paint flow. If you apply the wash on a tilted surface a bead of paint should gather at the bottom of each stroke without quickly dribbling downwards. While the paint is still wet you can brush further colours into it to create wet-into-wet effects, the thickness of the added paint determining how far it will spread into the damp wash.

Before tackling the techniques described in this book it is essential to have mastered the art of laying washes, not only because they are used in many styles of watercolour work but also because textured washes are created by breaking the traditional rules and that is what makes them such fun! As with many other facets of art, you need to be able to understand and follow the rules before you can break them successfully.

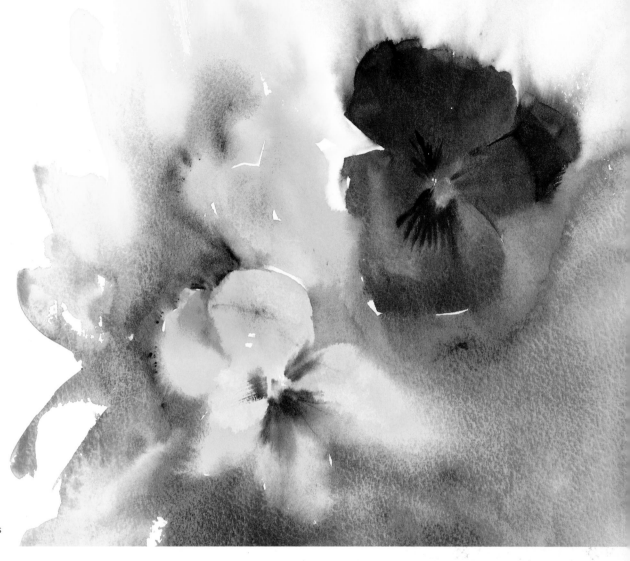

▽ To develop this random pattern I used a large round brush to describe rough marks. The right-hand bottom corner demonstrates an area of stippling.

Making the most of brushmarks

When the paint is not blended into an overall wash and gaps are left in the pigment the action of the brush becomes more apparent. You can use different sizes and shapes of brush to apply the watercolour in endless combinations of marks, such as skating dryish paint over a surface to create rough areas or combining it with patches of wetter paint for more varied texture; changing brush pressure from a firm dragging along the brush length to a swift flick of the tip; and developing textured areas through repeated stippling with the tip of a round or flat brush. Text-book washes often show the paint applied in horizontal strokes, but in real life it is usually more appropriate to apply the watercolour in a more random fashion. You will find that the subject usually dictates the direction of the brushmarks.

△ Pansies
27 × 30 cm (10^1/$_2$ × 11^3/$_4$ in)

The flowers were painted first with simple washes of colour. The background was then immediately painted around them, using the brush to create crisp leaf shapes along one side.

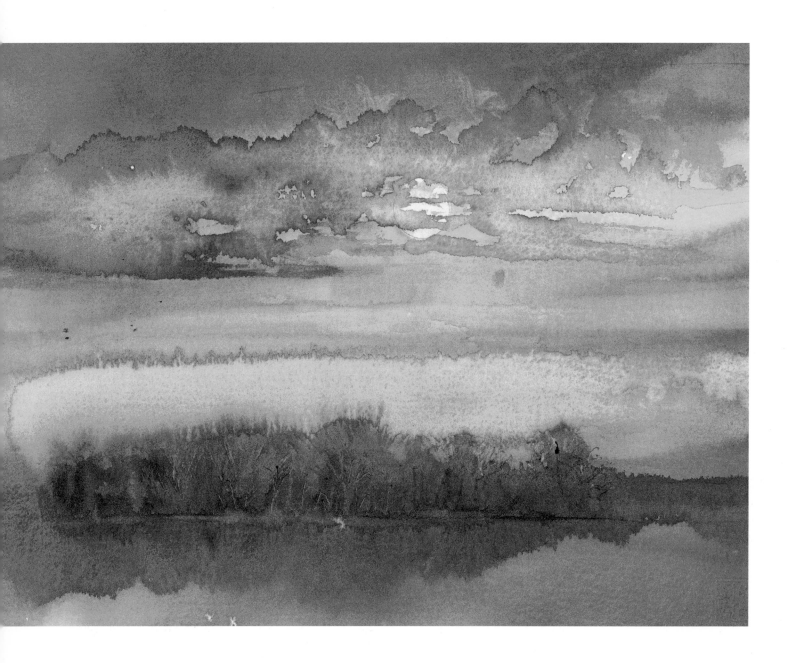

△ Sunset
19 × 25 cm (7½ × 10 in)

Horizontal brushstrokes
were laid across the paper,
with further paint applied
before they were dry. The
wash was pushed into
markings that immediately
suggested clouds and trees
even before the addition
of a few small details.

Using back runs

To achieve a flat wash it is essential not to go back
into the first application of paint once it has started
to dry; if you do so the wet paint pushes the drying
pigment into a ragged line called a back run.
However, you can choose to create this result
deliberately and employ it in a textured picture
to describe a wide variety of subjects from clouds
and trees to landscape contours or stonework. The
optimum time to aim for is when the sheen is
beginning to disappear from parts of the wash.

Washing out

This technique is similar to the one used to create a back run in that a wash of paint is disturbed before it has had time to dry completely, but using water instead of further colour. When areas of paint are almost dry but other parts are still wet, gently trickle or pour water on to the parts of the picture that you want to wash away.

This technique can be as unpredictable as it sounds when you first attempt it, but it can also lead to very exciting results. Timing is crucial, for if you add water too soon your entire painting can disappear, but if you leave it too long the paint may not want to shift at all. Paint can be washed out of small contained subjects or larger background areas. You can gently tease the water with a brush to help it move, but my preference is to allow it to go where it will.

If you want to gain a little more control over which areas are likely to be washed away you can use a hairdryer. Hold it close to the surface in order to direct the heat to particular areas you wish to retain. You can also use this method when creating back runs by drying the wash unevenly and blowing the wet paint around the paper.

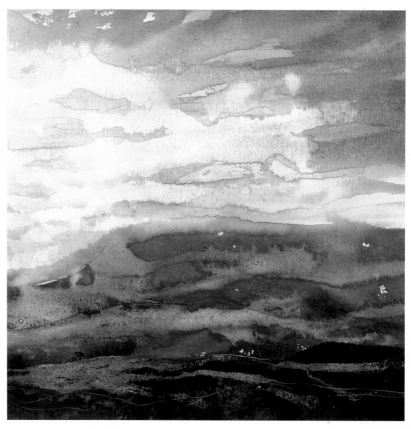

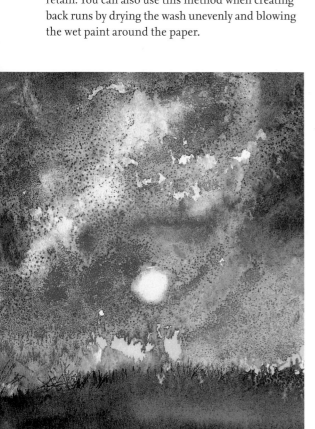

△ Water was dribbled into the drying variegated wash and the paper tilted on its side to allow the paint to wash away in horizontal streaks. The marks could be interpreted as layers of mist, clouds or mountain patterns.

◁ I blotted colour out of the damp sky with crumpled-up soft tissue paper to form pale cloud shapes. The moon was lifted out with a small firm brush almost back to the white paper.

Lifting colour

To create a different effect, lift or blot out colour from a damp wash using a brush or absorbent material such as a paper towel. If the wash has dried you can wet it again and lift colour to a greater or lesser degree, depending on the staining quality of the pigment used and the surface it is applied to. You can remove paint randomly to create texture or make specific shapes.

Explore further

• Blot colour out from a wash with paper towels, creating different-textured surfaces by using them flat, crumpled loosely and in a tight ball. Look at the effects that are produced and consider how you might use each of them in a painting.

Scraping

Lines, textures and marks can be scraped out of a damp wash using a variety of instruments to reveal the original surface. You will achieve the best effects by using the paint a little thicker or creamier than the standard wash consistency. The trick is to scrape paint off the surface rather than digging into it – the latter creates a darker and indelible mark where the wet paint sinks into the engraved surface rather than revealing a pale mark.

With the tip of a scalpel or knife, you can scrape away lines of different thickness to create textures such as grass, fur, a ridged shell or leaf veins. The edge of the scalpel or firm-edged bits of plastic can be used for chunkier subjects such as boulders or bricks – a credit card is very useful when chopped up for this purpose. The tool can be twisted and manoeuvred into curves or geometric shapes, depending on the subject.

▽ **Nest**
21 × 23 cm (8¼ × 9 in)

Some of the pieces of straw in the nest were described by scraping curved lines through the creamy brown paint with a scalpel. Other fine lines were made by dragging a paintbrush across the paper with a minimum of dryish pigment.

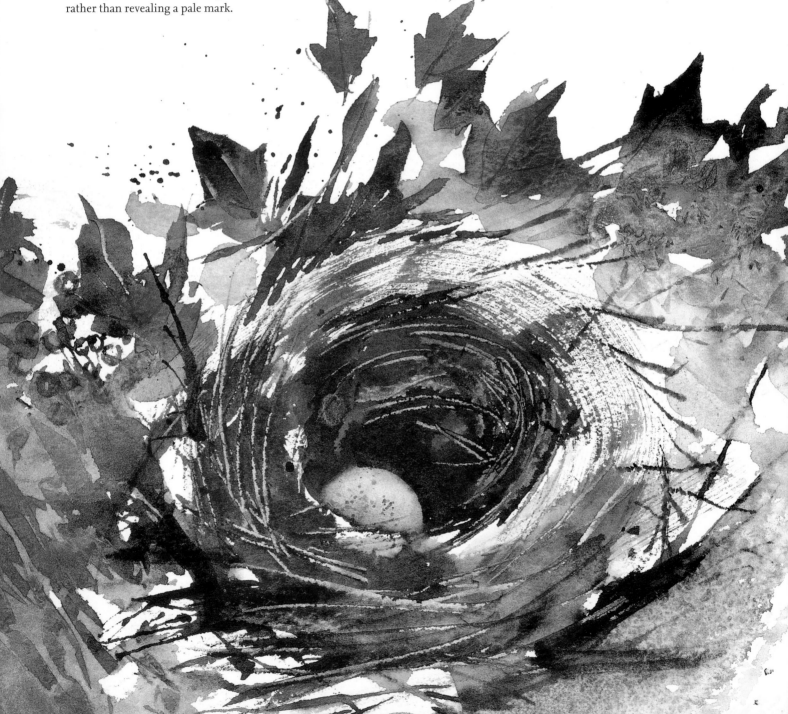

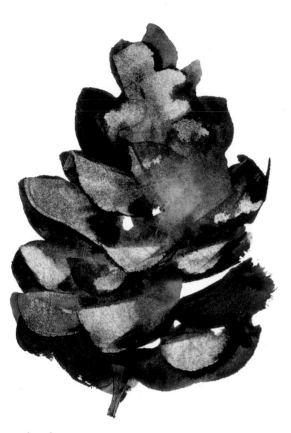

Scratching

Once the paint has dried it is not possible to scrape it in the same way, but you can scratch away the pigment and the top surface of the paper with the tip of a very sharp scalpel to create broken white lines or dots and pick out tiny highlights. You can also use an old-fashioned razor blade to scrape away the surface to make broken textures, especially on a rough surface. This is particularly handy for scenes with water where a sparkle is required. Be careful not to be too rough as you may tear the paper. Rub down raised bits of scuffed surface with a smooth tool or the flat of your thumbnail.

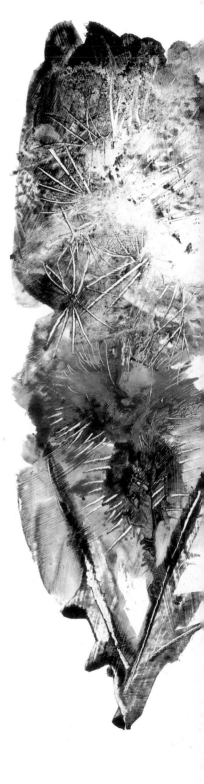

▷ Scratching and scraping works especially well on a smooth surface. The fine thistledown and spiky highlights on the thistle were easily removed from Hot Pressed paper.

△ The pale crescent markings that highlight the complex form of the pine cone were scraped out with a small piece of flexible plastic. I moved it in semi-circular directions to achieve the correct shape.

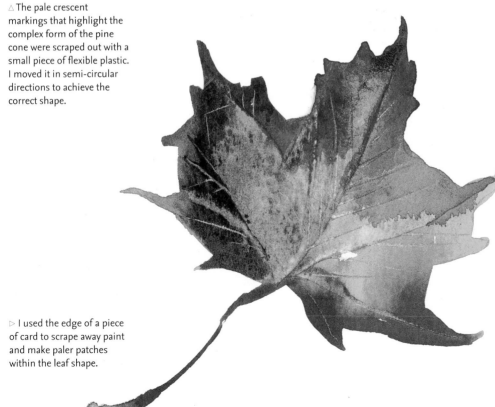

▷ I used the edge of a piece of card to scrape away paint and make paler patches within the leaf shape.

Using masking fluid

Masking fluid is an invaluable aid when creating texture because the random nature of such processes can make it difficult to keep an effect within a controlled space. Working carefully around a subject also uses up extra time, which can be critical when paint is drying quickly. By using masking fluid first to block out a subject, you can put in the surrounding background without constraint.

A solid shape can be filled in with a flat-edged rubber blender, or colour shaper – a multi-purpose tool with a rubber tip that can be used for applying masking fluid, blending pastel, scraping out and so forth. Alternatively, you can use the tip of your little finger to smear in big areas once you have masked the fiddly edges. Dots, lines or detail can be put in with a pen and nib or a ruling pen, which has an adjustable nib to vary the width of its line. You can draw clean, sharp lines of masking fluid with the edge of a palette knife, or print it on with the edge of bits of card, either straight or bent into curves. With repeated overlapping printing, it is easy to build up patterns. Once you have removed the mask, fill in the bare area with detailed paintwork or tint it as required.

If the masking fluid is applied onto a dry wash rather than white paper to build up background shapes or textures, some of the colour may lift off. However, this can be used to advantage as you will usually be wishing to create a paler mark or shape.

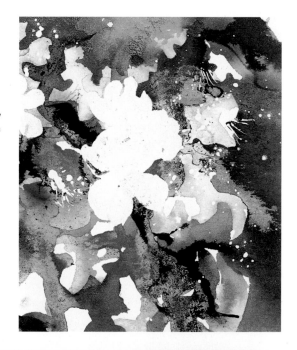

▷ In the first stage of the painting the overlapping blossom was masked out with a blender. The stamens were drawn in with a ruling pen and a few dots flicked in with a palette knife. Washes of colour could then be freely applied. Granulation medium and Sepia ink were added to the wet watercolour wash.

▽ Blossom
18 × 17 cm (7$\frac{1}{2}$ × 7 in)

After the masking fluid was removed the white shapes were painted in and the individual blossom details added. Areas of white paper left in the background prevent the hard-edged masked shapes being alien to the rest of the picture.

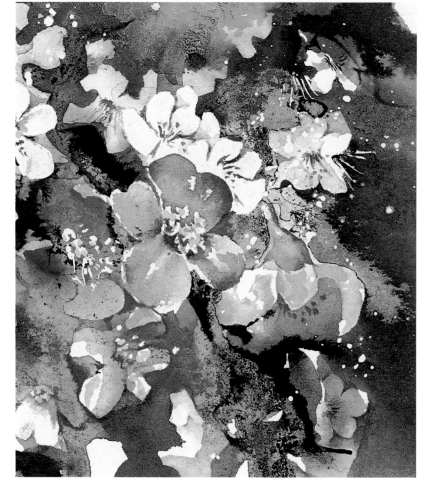

Studio tips

• When using masking fluid, the golden rule to avoid tearing your surface is to check that the paper is suitable first by trying out a good-sized splodge. Let it dry before painting, then let the wash dry completely through the full thickness of the paper before removing the mask. Use a hairdryer on the back and front of the paper to ensure it is not the slightest bit damp.

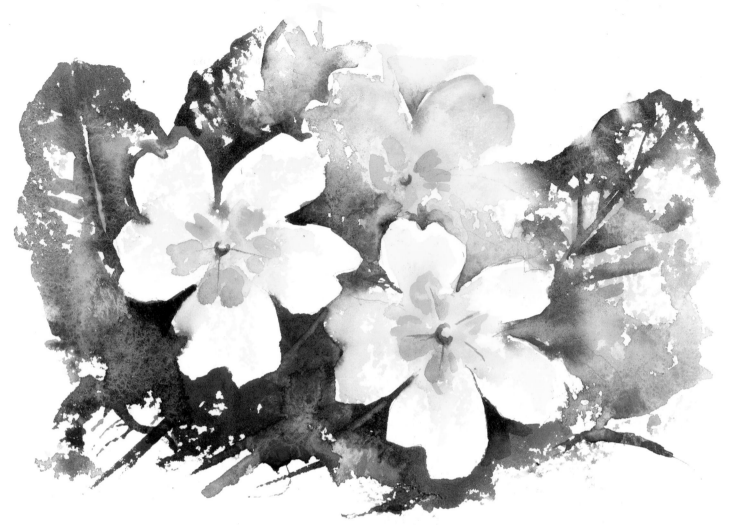

Toothed papers

Not, or Cold Pressed, paper has a tooth that aids the flow of the paint for luscious washes but is not so rough that it hinders any detail you may want to add. It will usually work well with all the techniques described in the previous chapter. My favourite Not paper is Saunders Waterford, as it is a very versatile, easy-going paper. I also sometimes use Bockingford for bright, fresh, 'one layer' paintings. It is easily disturbed and lifting out is effortless. This makes it great for texture-making but not so good for building up layers of work or washing-out techniques as too much paint tends to get washed away.

The uneven surface of Rough paper means that broken work is easily achieved. Paint skates over the irregular surface, leaving speckles and ragged patches of white paper sparkling through. The result is lively, sketchy or highly textured washes. Fine lines and detailed work are not so suitable on this paper and you may also find masking or scraping out difficult.

△ These primroses were painted on a Rough paper to make a loose, sketchy image. This surface helped to create irregular, broken brushwork that was ideal for capturing the knobbly texture of the leaves.

Studio tips

- Don't limit yourself to what you can find in an art supplies shop – try painting on all kinds of different types of paper, even textured wallpaper.
- You may need to use thicker watercolour or gouache with more dominant papers. Use gouache or add opaque white to watercolours in order to paint on dark or coloured surfaces.

▷ Watercolour was applied to a board primed with gesso using a brush. The smooth surface has resisted the paint to create a marbling which is peculiar to this surface.

Working on mountboard

Using mountboard rather than paper will give you totally different and wonderfully exciting effects. I use the back, or smooth, side of the board. It needs to be primed first as the surface would otherwise be too absorbent, and this can be done with white gesso primer.

The way in which you lay the gesso on the surface affects the finished painting as the textures can show through the subsequent paintwork, depending on the techniques, thickness of paint and medium used. A coarse hoghair or house painter's brush will leave obvious brushmarks which you can stroke on in directions to suit your subject; you can stipple the gesso on, or apply it smoothly with a softer brush. A roller makes another sort of raised surface texture, or you can employ palette knives to create a smooth or layered finish.

Applying paint

Once the gesso is dry, apply paint in the usual ways. The pigment sinks into any slight crevices or marks in the gesso and creates immediate texture. Dryish paint can also be lightly dusted over the surface to catch any raised areas or brushstrokes. Conversely, pigment can be lightly wiped off any prominent parts of the surface – either method can help to build yet more layers of texture.

Acrylic paint is more traditionally used on this type of surface as the gesso can resist dilute watercolour, making it shrivel and create confluent blotches. This may be a useful effect in a particular painting, but if it's not what you want you will find that second layers of watercolour do adhere better, allowing you to develop more solid paintwork. I usually use quite creamy, thick watercolour on top of gesso and this can be manipulated using many of the methods normally applied to paper. However, paint is much more easily removed on the less absorbent surface and can be lifted out or blotted almost back to the white gesso if required.

Texture paste can be applied instead of, or in conjunction with, gesso to create more pronounced texture. If used thickly you can scrape and scratch through it or press objects into it. Try cutting specific shapes out of material such as thick cardboard or potatoes to print the paste on as a positive mark or to press into a layer of paste and leave a negative shape; experiment too with different tools, including a palette knife.

◁ I applied texture paste thickly then scraped through it in a feathery pattern. When this was dry, I used coloured ink which either sank into or avoided the furrows and then rubbed gold paint over to catch the ridges.

▽ In this detail from *Moorland Sheep*, the sweeping brushmarks of the gesso primer following the forms of the landscape can be clearly seen through the tints of watercolour.

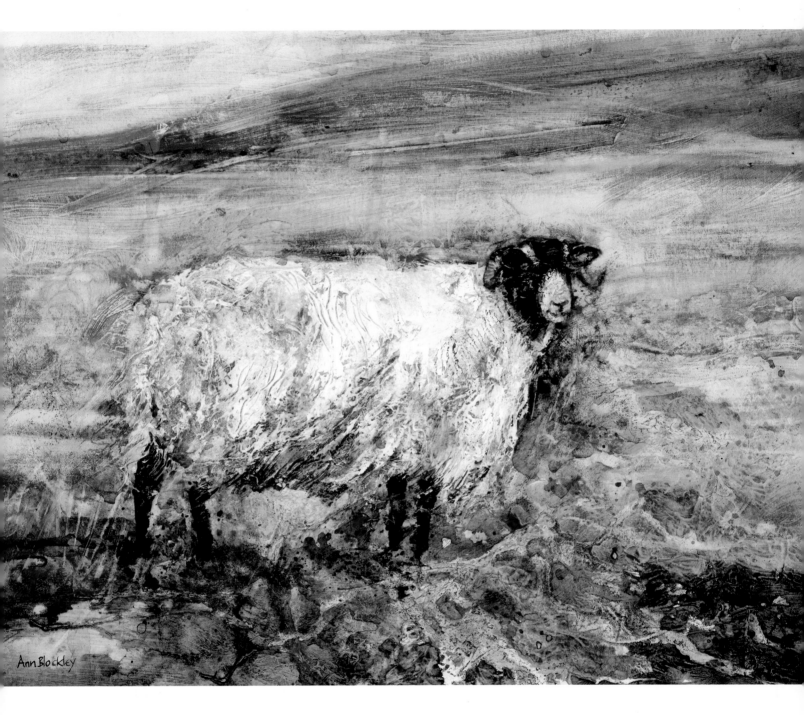

△ **Moorland Sheep**
27 × 36 cm (10½ × 14¼ in)

The background was painted
on a gesso base and the
sheep's woolly texture was
created by pressing wispy
strands of wool into texture
paste, then applying gesso
over the top.

Studio tips

- Go to your local picture framer and ask for some
 mountboard offcuts – when window mounts are cut
 the middles are often discarded and can sometimes
 be acquired very cheaply.

Acrylic paint

Acrylic paint is included in this book because it is a water-based medium and can be used in similar ways to watercolour, albeit possessing quite different qualities. Once it is diluted it can be laid like watercolour in transparent, loose washes on primed mountboard as described on pages 34–35. The diluted mixture falls into the textures of the gesso and when this is dry, thicker paint can be built up on top. As it is applied more thickly the pigment becomes more opaque so that, unlike in the case of watercolour, pale colours are easily placed on top of dark tones.

The drying time of acrylics is much quicker than watercolour, but adding a retarder to the paint will slow down the process. Once dry the paint is waterproof, so any lifting techniques need to be done while the paint is still wet. The advantage when working on board is that layers of acrylic can be built up without the undercoats being disturbed, as can happen when using watercolour on such a surface.

▽ Cotswold Snow Scene
26 × 35 cm (10¼ × 13¾ in)

Layers of acrylic paint were built up on a textured gesso base. The final coat of dryish white paint was lightly laid over the darker colours so it gathered only on the raised brushstrokes. Other parts were lightly rubbed when almost dry to reveal parts of the previous layers.

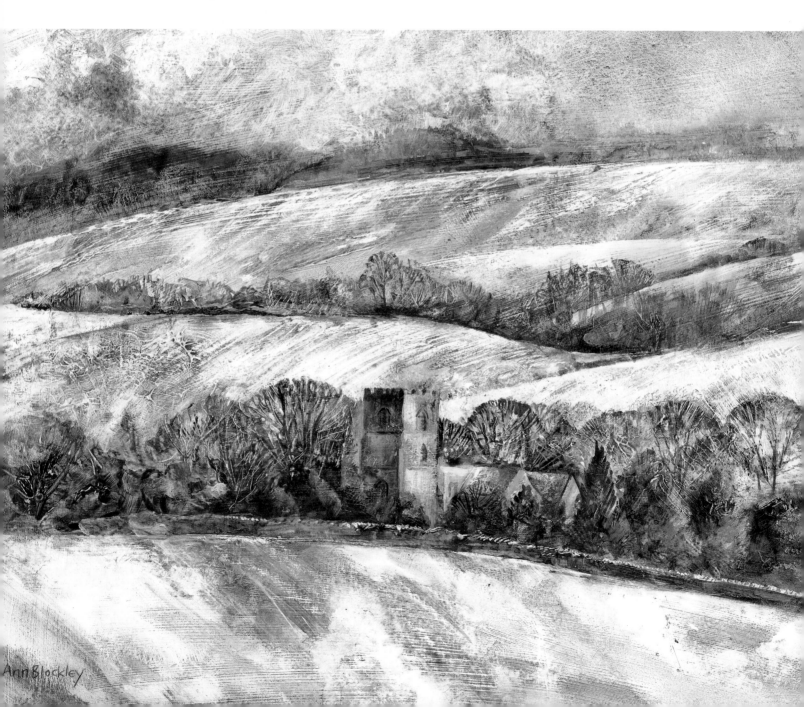

Ann Blockley

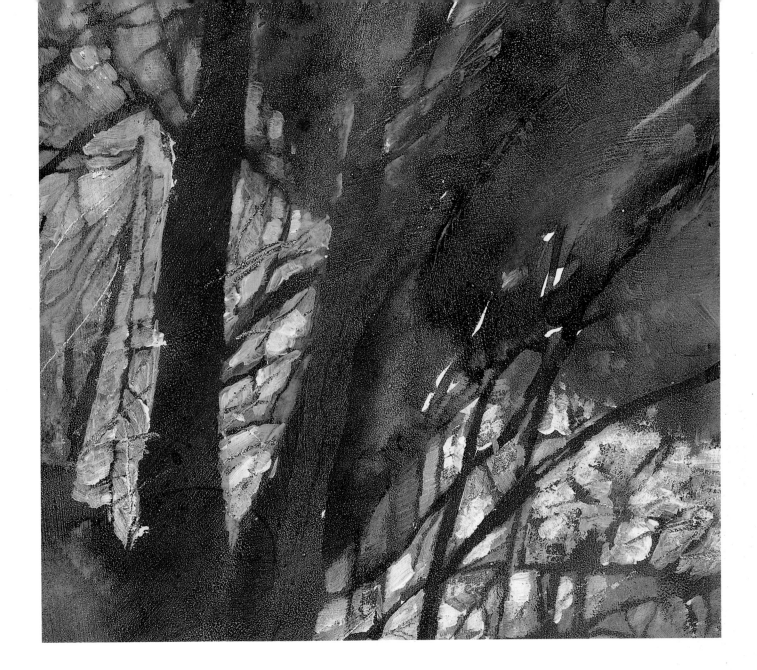

△ A base of various acrylic ink colours was applied over a piece of board. When this was dry, negative shapes were picked out with pale acrylic paint so that the ink remaining took on the semi-abstract pattern of branches.

Acrylic ink

Unlike most types of ink, acrylic inks are waterproof once they are dry and, even more importantly, they are lightfast.

I like to use acrylic ink as a base coat for further painting. It is a lazy and easy medium to work with, since it can be used straight from the pot and on to the surface. However, it takes a brave artist to use inks undiluted, as they are extremely vibrant! Alternatively, colours can be combined or diluted on the palette or added to acrylic, gouache or watercolour paints.

Explore further

- Black Indian ink is another useful medium. Being waterproof but containing a lot of sediment, it reacts with wet watercolour to create speckled, grainy textures. This result is even more dramatic when used in conjunction with granulation medium. A similar effect is obtained with Sepia acrylic ink.
- Combine Indian ink with watercolour in a landscape painting to create a stormy sky or the foreground textures of mountain or moorland. Use a restricted palette to imbue the painting with a distinct mood.

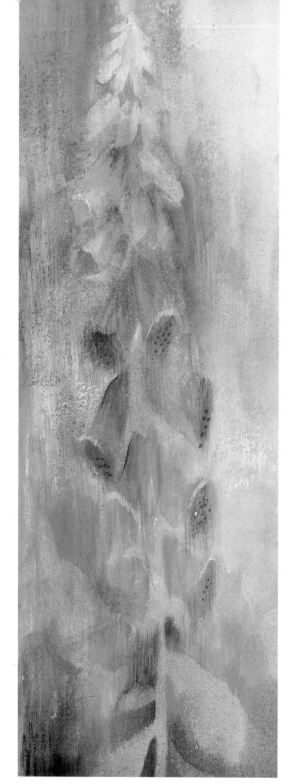

Creating texture with gouache

Gouache is an extremely useful paint to complement watercolour. The two sister mediums can be used in similar ways, both being water-based but, unlike acrylic, not waterproof when dry. The big difference between them is in the opacity of gouache; pale colours can be overlaid on darker ones or different colours layered on top of each other.

Gouache may be diluted to a watery consistency to make it almost as translucent as watercolour, but its character is in its chalky solidity so, to make paler shades of gouache, it is better to add white to colours instead of just diluting them. There are also different methods for blending colours; wet gouache will react like watercolour and virtually blend itself, but different colours of thicker or dryer paint will have to be feathered together with brushwork. The paint can stippled or cross-hatched to build texture.

Watercolour and gouache may be combined happily within a picture. For example, you might choose to paint watercolour washes as a first stage and then add subsequent gouache layers (but do not try this in reverse as it is important to work from thin to thick paint). Sometimes you may want to add just small amounts of gouache to a watercolour painting, perhaps spattering pale gouache over dry background washes to give texture if they need livening up or look too solid. White gouache is especially useful for painting pale shapes on top of a dark watercolour. It is also possible to work on coloured paper as well as on prepared mountboard or even collage for a heavily textured effect (see pages 40–41).

▷ **Sheep on the Hill**
30 × 26 cm (12 × 10¼ in)

I painted dilute washes of gouache on primed board then built random brushmarks of thicker paint over this to describe the hillside. I scraped through the gouache or printed lines to represent grasses, then painted in the sheep on top.

Studio tips

- Applying small amounts of undiluted pigment with a dry brush on dry paper is ideal for creating broken, scumbled textures.
- Dragging paint with a flat-edged coarse brush produces textures resembling hair or wood grain.
- Scrubbing movements made with a round brush can be used to develop more random effects.

△ **Foxglove**
34 × 12 cm (13½ × 4¾ in)

A pale wet-into-wet wash of watercolour was used to cover Hot Pressed watercolour paper. Gouache was then painted on top with a variety of dragged or blended brushstrokes. The edge values of the foxglove were kept very soft and detail was left to the minimum in order to create an impressionistic mood.

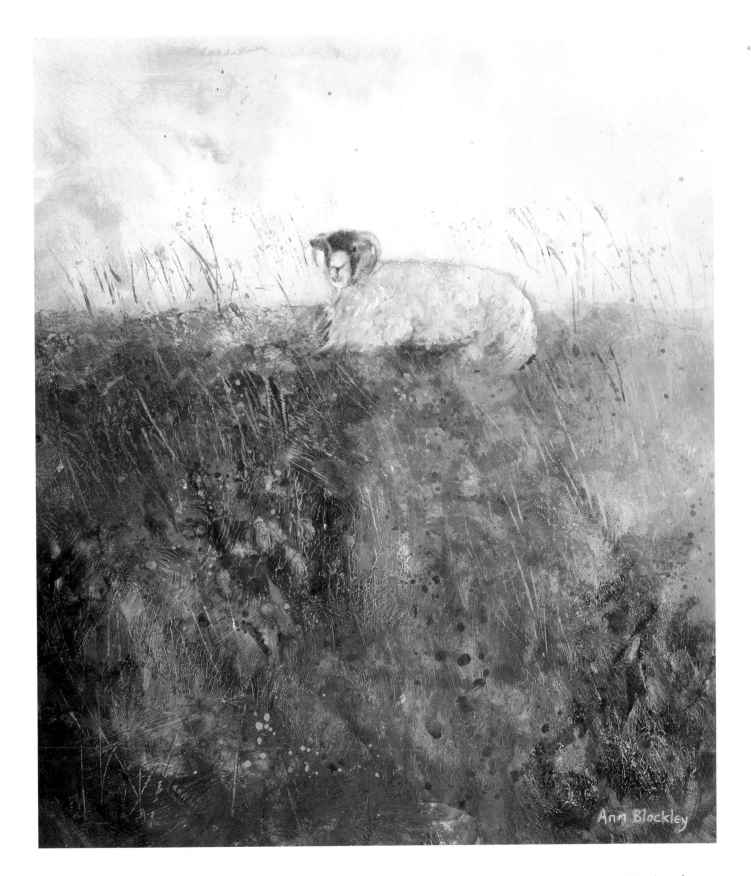

Ann Blockley

Constructing a collage

Working on mountboard with an undercoat of gesso and texture paste opens up a whole range of options and ideas for further experiments. Both gesso and texture paste act as a sort of glue, and this means that a collage base can be developed by sticking other materials to the surface. Heavy material such as lace, wool or thick wallpaper may need the help of some PVA glue to ensure it is securely stuck into place. The base may also need repriming if absorbent material is added.

Acrylics, inks and gouache can all be successfully used on a collage surface. In pure acrylic painting there are probably no boundaries as to what you can add to the collage, but in more watercolour-orientated pictures there is a limit to how chunky the added material can be for a successful result. I prefer to keep the surface relatively flat, with rough, frayed, torn, ridged or holed material adding texture and relief.

Collage materials

When you are using watercolour over raised areas of collage you will often obtain the best results with thick paint or more opaque pigments. However, for thin paper such as tissue or newspaper a transparent glaze may be suitable.

Magazine cuttings make for interesting collages, perhaps stuck onto a painted base then partly repainted to incorporate them into the picture. Gouache and acrylic paint work better than watercolour if the surface of the added collage has a glossy coating.

You will find all sorts of mediums in art shops that help you to create textured bases for collages. These are usually designed for use with acrylic paint but work well with thick watercolour or gouache too. However, many of these prepared substances can be made at home with a bit of imagination. Sand, glitter or any other fine particles can be scattered into damp gesso or texture paste to create unusual areas of surface that will then combine with the collage materials.

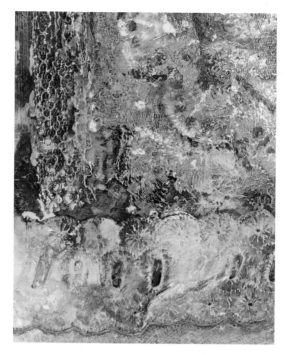

◁ Different types of lace were used in this collage sample. I ripped and frayed the flimsier laces and let the more solid material crease and crumple as it was stuck down. The paint fell into the holes and recesses but was easily wiped off the raised parts.

▽ Landscape Collage
10.5 × 12 cm (4¼ × 4¾ in)

Coloured tissue paper was torn into water and mountain shapes and applied with PVA glue to mountboard. A small house was cut from a magazine and stuck onto the scene. I then created a cohesive picture by painting over areas of the collage with gouache.

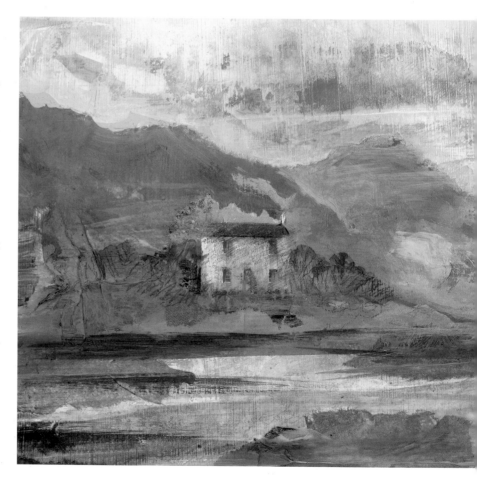

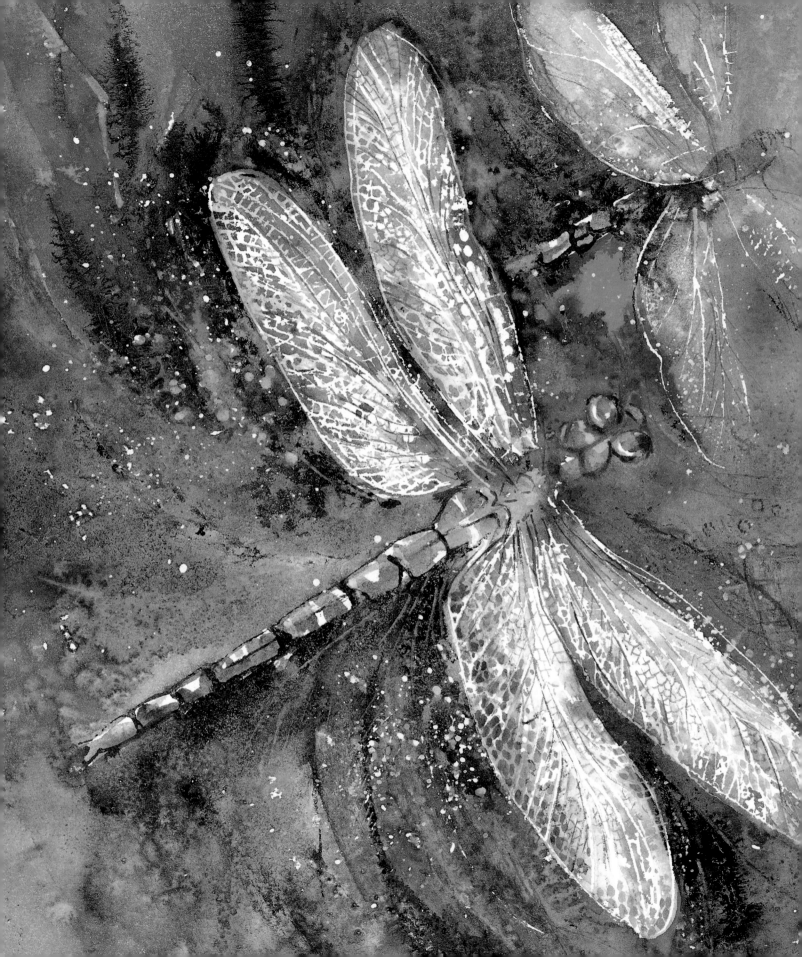

The creative process

This is probably the most important chapter, since techniques can be learnt but developing the ability to look at the world in a creative way is harder. The artist has to step outside preconceived ideas and view subjects as if for the very first time. Students sometimes look at complicated subjects and feel lost as to how to proceed, but that is the whole point: to lose yourself in the subject and enjoy it and the paintwork for its abstract qualities.

Most of the following ideas involve using your imagination, playing with the paint and glorying in its texture. If you give yourself permission to fail, to waste materials and to lose control, the process becomes more enjoyable and ultimately much more useful in your progression as an artist.

◁ Dragonflies
20 × 27 cm (8 × 10½ in)

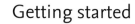

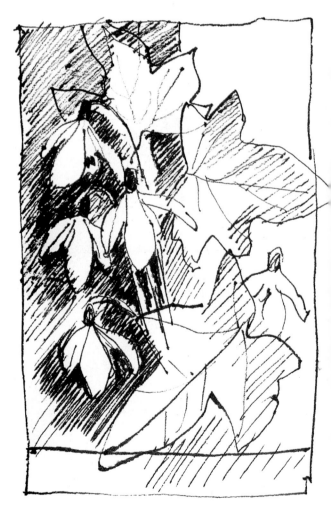

Getting started

Some people believe that getting started is the hardest part of the creative process but, maybe without realizing it, you have started your painting at the very moment you look at a subject and register interest. What can be difficult is actually defining the quality within the subject that has caused your initial excitement in order to capture that in paint.

Sometimes it is immediately obvious; a colour, a certain light or shape simply shouts at you. At other times the more a subject is analysed, the more it can confuse and bedazzle by presenting a plethora of features, all worthy of portrayal. It may help here to allow yourself two options. The first is to pretend that you are seeing the subject for the very first time and have no preconceived ideas. Look at it only in

Here is a selection from dozens of my doodles, drawings and thumbnail sketches of snowdrops made in felt tip, pencil or pen. They are mainly monochrome explorations as at this stage my principle interest was in shapes. Combining the flowers with ivy leaves was an extension of this fascination with pattern and design.

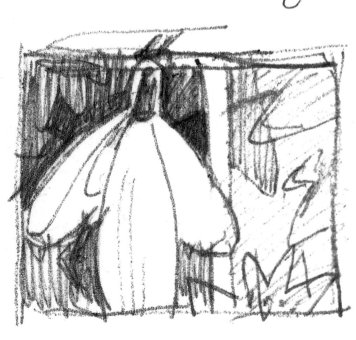

abstract terms such as 'crisp', 'white' or 'simple' and permit only two or three descriptions which will become the priority. There are always more words that could be added but that is when the confusion sets in. If the main focus of the ensuing artwork is on describing those few words in paint, the finished picture should clearly express that earliest vision.

The second option is to embark on a thorough exploration of the subject through sketching and drawing. Doodle on scraps of paper, sketchbooks or the backs of old paintings with any drawing instrument to hand; look at shapes, positive, negative or overlapping. Study tonal values, textures and patterns and play with compositions and formats. As you draw, you will organize your thoughts and thus gain the confidence you need to embark on the painting proper.

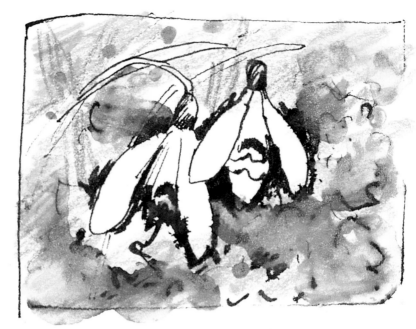

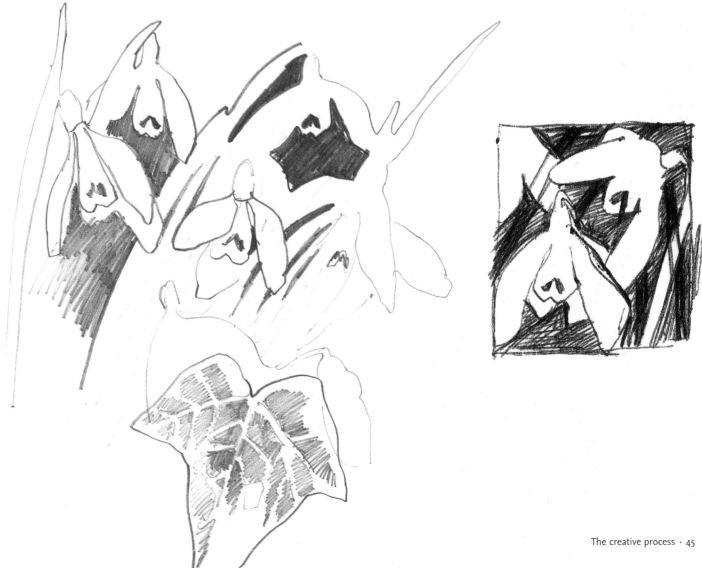

Putting paint to paper

Once you have thought about or explored your subject through drawing you can begin to make choices and decide on the contents of the painting. You may find it really hard to make the decision to drop some ideas that seemed good but ultimately won't fit into the painting successfully. Conversely, you can allow yourself the luxury of combining elements from more than one sketch to help the creative juices to flow.

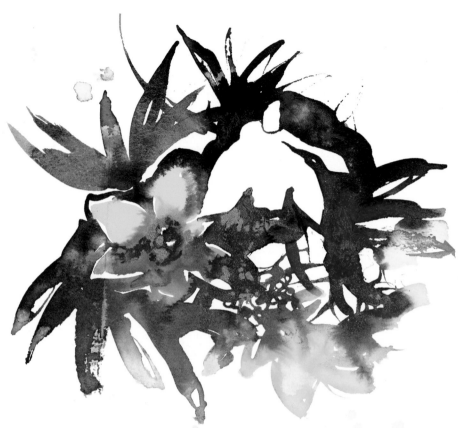

▽ I tried dropping silver ink into a dark background to give a frosty or wintry theme for a painting of snowdrops and winter aconites. I had explored the possibility of this subject combination in one of my sketches on pages 44–5 and decided to take the idea further.

▷ This paint doodle is a colour rehearsal for *Snowdrops and Winter Aconites*. I did eventually use the silver ink idea in another snowdrop painting but thought that I would prefer a warmer palette for the rich glow of the aconites.

Choosing a colour palette

Having decided upon how you will tackle the subject in terms of composition, you will then need to explore various colour themes. Often the decision may be clearcut but even then it is worth trying out combinations of paint on spare paper before you touch the chosen surface. You will find that this process of choosing colour doubles as a warm-up session during which you can try different types of brushstrokes and textures and learn which techniques suit the subject. Because these are only rehearsals, you will be able to paint quickly and without fear, and thus produce results that are loose and painterly. The secret of success is to transfer this spontaneity into the finished picture.

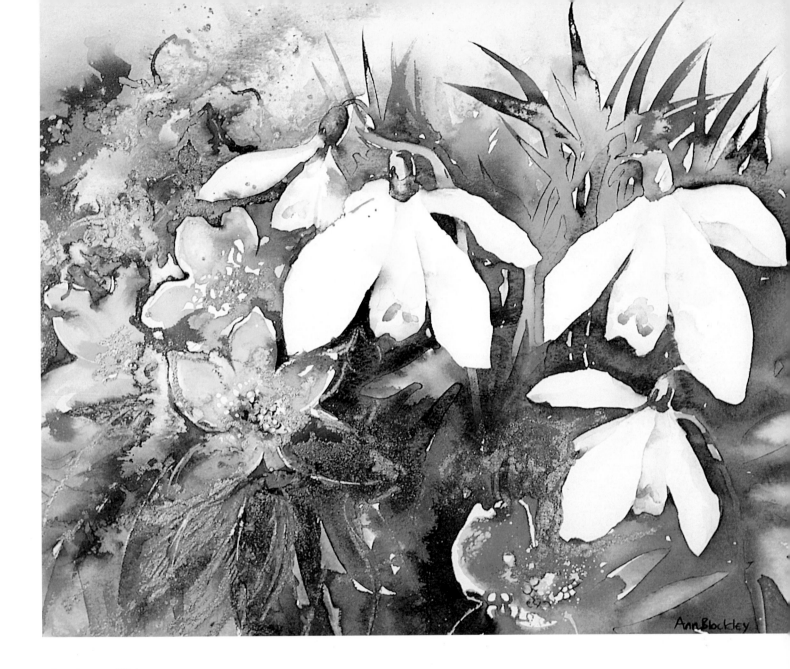

△ **Snowdrops and Winter Aconites**

29 × 37 cm (11½ × 14½ in)

The sharp simplicity of the white snowdrop shapes contrasts with the more complex interpretation of aconites. There is a direct progression from the colour rehearsal to this finished version. The idea of the spiky leaves hastily explored in the sketch is developed in the painting with a washing-out technique that gives a hard-edged but faded quality.

Explore further

• When you have explored a subject with sketches and feel ready to paint a considered picture, don't think of it as 'the finished painting'. See it as just one more stage in the creative process and embark on a second painting if the first doesn't turn out as planned.

◁ Random paint splashes soon took on the form of poppies with the merest hint of a centre and stamens added to nebulous rounded red or pinkish shapes, leaving the viewer's imagination to do the work.

Finding inspiration

We have considered the process of analysing the subject then trying to capture the particular quality or combination of ideas that emerges, but paintings do not always develop in such a linear or logical manner. You may sometimes have a less tangible idea or emotion, in which case simply play with paint on paper just to see what happens. This is also a useful way of working if you feel lacking in inspiration or want to release yourself from 'artist's block'.

Try setting yourself a very general theme to suit the mood you are in. This might simply be the idea of taking a colour, for example red. Begin by mixing different reds, from cool ones to warm. The reds need other colours to complement them, so mix further pigments, some that clash and contrast, others that blend and soothe. When these are brushed and splashed onto the paper in happy red abandon, you might suddenly see them as poppies, for example. Some may appear to be soft background field poppies, while others are strident garden poppies singing in the full sun. Spatter in flecks of black ink, and turn some of them into poppy centres. You might notice that reds combined with ochres suggest a harvest theme, and decide to scratch and scrape lines to create a brittle field of barley. The ideas for a painting slowly take shape.

Using your imagination

The experimental exercises, paint doodles and rehearsals that my students undertake demonstrate a sumptuous freedom that often disappears as soon as we turn to 'the real thing'. At that point the inhibitions creep in and the painting tightens. One method that acts as an aid to overcoming this problem is to work back to front – in other words, pleasing samples of preliminary washes and textures are taken and turned into finished work, rather than planning a picture and painting washes to order.

This way of working involves using the imagination and keeping an open mind. The watercolour at this stage is just an abstract area and the idea is to look into it and see what the marks and textures suggest. Then paint can be added or removed and details included until a representative image emerges. This has to be performed using methods that are sympathetic to the original sample and do not hide or destroy its attractive, loose character.

▽ Rummagin[...]
selection of [...]
for ideas, I w[...]
similarities [...]
splodge an[...]
I had taken [...]
are related [...]
marks an[...]
watercol[...]
the vase [...]
the ph[...]
I was a[...]
abstra[...]
realis[...]

Developing ideas

Abstract ideas can lead to substantive matter, as in the above leap from 'red' to 'poppy'. Once you have arrived at a physical subject, in this manner or simply chosen at random, you can develop it even further.

For example, if you had arrived at the word 'cobweb', you might start to focus on techniques for describing suitably delicate lines and tracery patterns. This in turn might lead your thoughts to lace effects, then on to pale lacy cow parsley interwoven with spidery hedgerow plants. You would then start planning the background that would show this to advantage, and the textures you could use to describe your subject, and again the composition for a painting would emerge.

When you are feeling stale or uninspired, using these techniques will reignite your enthusiasm until the ideas flow. Your experiments can act as an aid to stimulate the initial ideas or they may follow on from thoughts that occur at the choosing or drawing stage. Either way, it cannot be emphasized too much how vital a part this playing with paint, texture and colour is to the creative process.

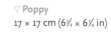

▷ Using dark paint around areas of Cadmium Red makes the colour appear more vibrant. Scratch marks suggest grasses and provide movement.

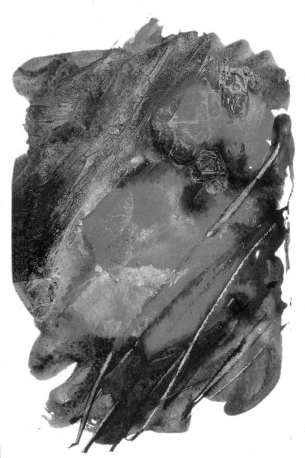

▽ **Poppy**
17 × 17 cm (6¾ × 6¾ in)

This poppy started life as an enjoyable experiment. I often prefer the results of paint doodles like this to more planned work. I liked the contrast here of rich blue and red against the marbled striations of ink and so developed petals and a centre to give form to the flower.

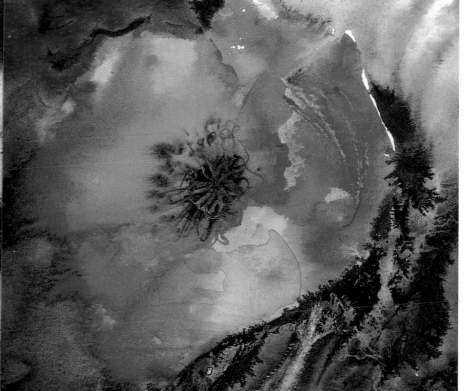

Explore further

• To stimulate some ideas, look around the studio and choose an object. Imagine that it has been magnified much larger than life so that the textures or patterns become abstracted, then play with paint to find a technique that describes its markings.

▷ Washes were broken up with dribbles, back runs and blotting out. A small crisp patch of white paper was missed and stands out from the watercolour. The background marks suggest a landscape and sky. Could the sharp shape be softened and lifted out to make a moon? Or could it be adjusted to become a white bird in the sky?

Creative cropping

Be aware of the possibility of cropping your work, even at the experimental stage. You may decide that a section, while pleasing in itself, doesn't fit with the rest of the work, so just recompose the painting by slicing it off. You can then go on to develop both pieces of work, which will probably diverge even further in character as you progress.

A handy way of viewing possible crops is to cut an old mount into two separate corner pieces that can be adjusted into different sizes and shapes. These can be moved around paintings for the final cropping or used for choosing rectangles out of an abstract area that may be suitable for development. A similar smaller rectangle could be used as a viewfinder which to look at and compose subjects.

PROJECT Developing abstract marks and textures

Painting is often a series of problem-solving: you have to draw accurately and find the right colours, the best composition and most relevant textures to express an idea or make your subject recognizable. All the decisions that you have to take can dampen the sheer enjoyment gained from simply playing with pigment on paper and the adrenalin rush that comes from taking risks with it and pushing it into textures.

To avoid this happening, give yourself some play time and cover surfaces using different colours and texture-making techniques. Your focus should be on the actual textures and marks without planning a specific subject – in other words, each piece should be completely abstract. The next stage is to take one that pleases you and decide how it can be developed into a painting. There may be certain marks or shapes that hint at a subject, or the overall texture may suggest a background into which other elements could be incorporated.

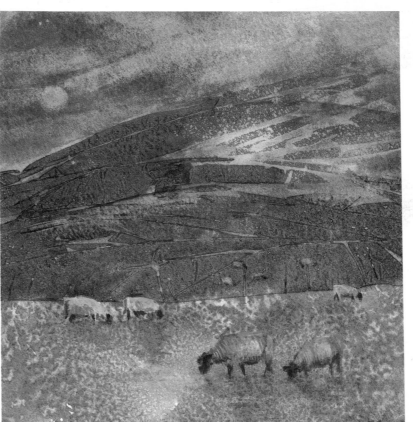

△ This conjures up a landscape image because of the directions and shapes of the clingfilm markings. A texture such as this can be developed in many ways, as I proceeded to do in *Sunset Sheep*. Lifting and blotting can lighten and smooth out areas that need to be plainer, although only non-staining pigment is successfully removed. Paint could also be added to disguise or embellish as required.

◁ Sunset Sheep
13 × 13 cm (5 × 5 in)

The abstract base for this painting was a combination of salt and clingfilm textures, laid in strips. The colours suggested a sunset-lit landscape, so I softened the top of the square to create a sky and lifted out a hazy sun. I added gouache sheep to the salt-speckled meadow area.

Lateral thinking

Try to think laterally when you are looking at your abstract paintwork. Skies, for example, are not always shades of blue: they may be mauve, yellow, or even moody brown. Landscapes can also be any colour you like depending on the light, the season or the mood you are trying to create, and towns can be painted red! Your picture does not have to be realistic – let yourself enter the realms of fantasy and imagination.

The brain is programmed to interpret objects as they normally appear, so if something is presented in a new way we may not immediately recognize it, especially if only a section is shown. If you magnify a subject to much larger than life, the textures within it will also enlarge and seem more abstract as they increase in size. Visual tricks such as this, showing enlarged sections of an object, are commonly found in puzzle books. Try a similar concept when viewing your painted texture – you may find that it speaks to you in a different way and that the possibilities for its development will increase.

Choosing your method

You can build your picture from its abstract beginnings using any method you prefer. If you need to do any drawing first, use a soft pencil on light areas; pale watercolour pencil lines are more visible on top of dark pigment. You can darken the tone of your painting in parts, modify your colours or soften your textures with further washes of watercolour. Other areas could be blocked out with paler paint – gouache is especially useful for this, being opaque. You may want to wash away or lift some colour or add more layers of texture. The choice is yours.

▷ These meandering mottled rivulets were caused by granulation medium dribbling its way through paint on a gesso-treated surface. This is a section plucked from a much larger piece. How it is interpreted or developed will be influenced by the format I choose. Viewed vertically, as shown, it is reminiscent of plant life or lichened tree forms. If you turn the book on its side and view it horizontally, a landscape or rushing stream is suggested instead.

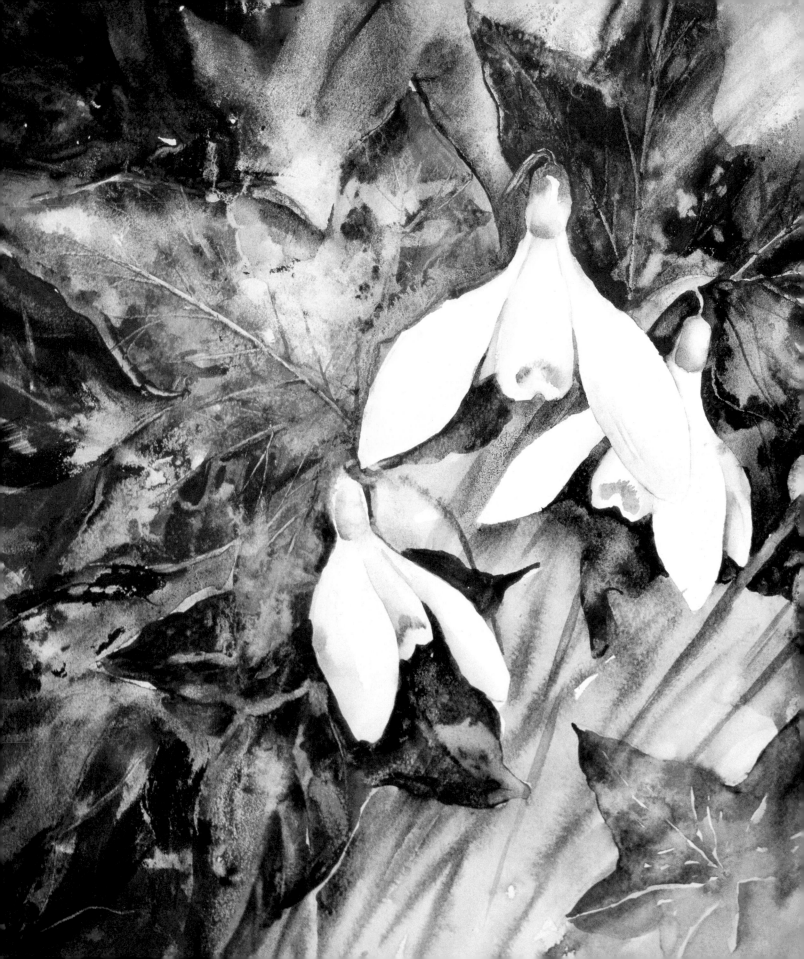

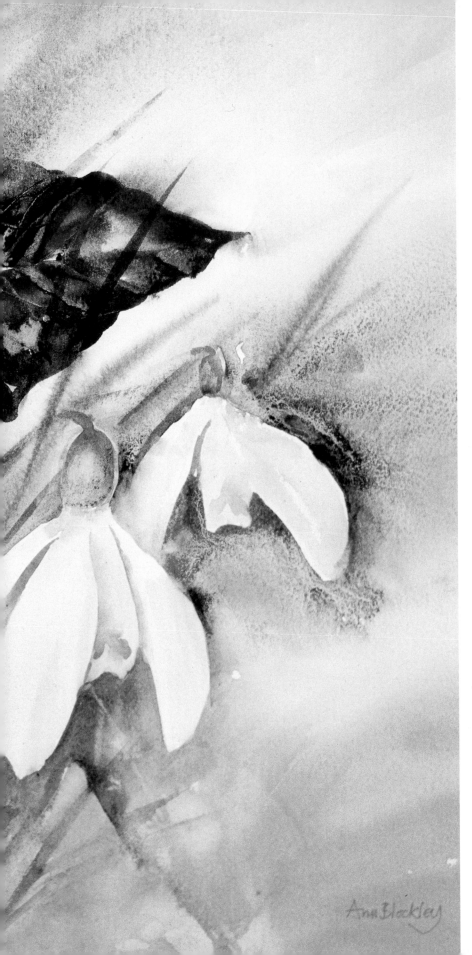

Flowers and foliage

Many artists find flowers and foliage a source of joy. They offer a range of possibilities in their treatment, from a straightforward botanical style to abstract renderings, and they can be viewed as a series of shapes, colours, patterns and edges, which, against different backdrops, provide a feast of textures and mark-making.

There is great pleasure to be gained from regarding the background and the flowers and foliage within it in a loose, textural, impressionistic or stylized fashion. It is equally fun, albeit more difficult, to look at the main subject itself in such a way. The variety of approaches you can take makes flowers and foliage perhaps the most exciting, versatile and challenging of any subject you can tackle.

◁ Snowdrops and Ivy
29 × 39 cm (11¹⁄₂ × 15¹⁄₂ in)

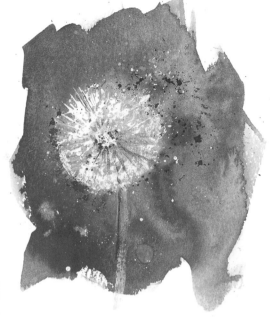

Creating a mood

Botanical studies are primarily concerned with an
accurate description of a plant, but outside that
particular genre most artists aim to make their
flower paintings atmospheric. There are warm, soft
pictures and cold, brittle ones; winter scenes and
summer; cheerful afternoons or fading twilight.

The mood that you choose to convey to the viewer
with each painting may be formal, fun, romantic,
melancholic, shocking, peaceful and so on. All
these variations can be successfully evoked through
the skilful use of different colours, tones, techniques
and edge values.

The juxtapositions of the elements in the
composition also set the character of a painting;
a series of dandelion clocks combined with golden
buttercups will have a very different aura to a lone
clock posed dramatically against a contrasting
background. Scale also has a bearing, for a larger-
than-life flower has a different personality to a
miniature version.

Texture and mood

In textural terms, the use of smooth finishes and
horizontal marks promotes a feeling of calm, while
busier textures with vertical, diagonal or swirling
strokes invoke a livelier mood. A happy feeling is
created through the use of bright colours and these
will appear even more vivid when they are applied
in a textural way that allows bits of white paper to
shine through, either as dots or as bigger gaps
between each paint mark. A more even, solid wash
of paint will often seem more restrained and
subdued. Similarly, hard-edged or jagged marks
and patterns are more upbeat than curvaceous,
soft-edged marks and textures.

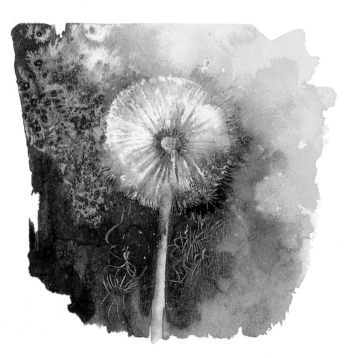

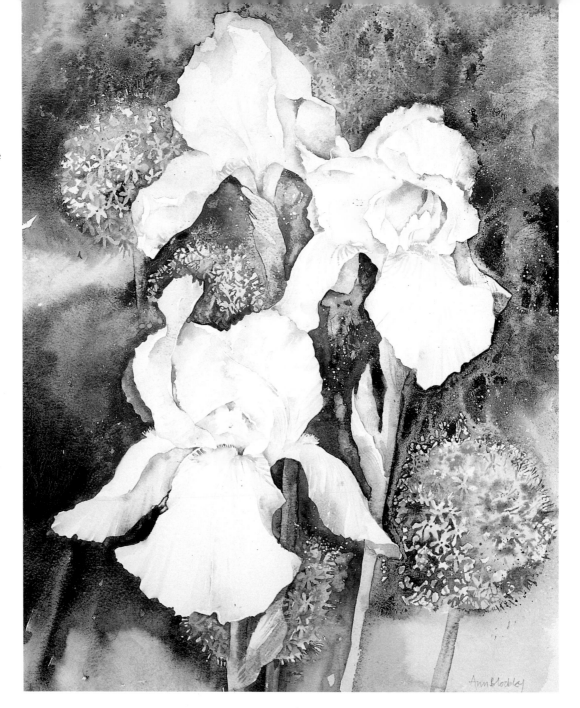

The pale, crisp-edged iris stands out from the contrasting background, where salt sprinkled into the washes created mottled blotchy textures. I worked into these marks to bring out the tiny florets of the allium flowers. The distant ones are simply hazy amorphous shapes.

Backgrounds

Backgrounds can play a vitally important role within flower paintings, helping to create different settings and atmosphere through their colour and texture. When you are deciding which pigments to choose, take your cue from elements that exist within the flowers and foliage themselves; the colours and marking of petals, stems or even stamens, which in some species are very attractive, can all suggest the choice of background. The time of day or the season may also influence your decision as to how to paint your background.

Simple backgrounds
A complex flower may need the contrast of a simpler background, but you can still include an element that links the different areas, such as allowing speckles on petals to spill into the background. Make use too of marks that serve an appropriate function such as adding movement or flickers of light, or sub-plots like foliage or scattering seeds.

Background flowers

The flowers or foliage that I include in the background are painted as loose impressions which only hint at their identity. They are semi-abstract like the paint doodles on pages 48–9, but this time they are largely planned, with happy accidents teased into shape until they take on meaning. The viewer is left to work out their own interpretation from the clues, which helps to weave an air of mystery. The impressions may be further versions of the main flower or a new subject.

To create depth in your picture, paint the main flower harder-edged and more detailed than the background ones. This has the effect of making the foreground focal point more prominent, while the soft-edged impressions recede. By the same token, it is important to watch out for any areas of texture within a background that are too definite in relation to the subject. The idea is for the backdrop to complement rather than dominate the focal point and it may advance too far if it is made up of very strong contrasts either of tone, colour or edge value. Any large textural elements will come forward and should therefore be planned to serve a particular purpose, such as suggesting further leaves or flower shapes.

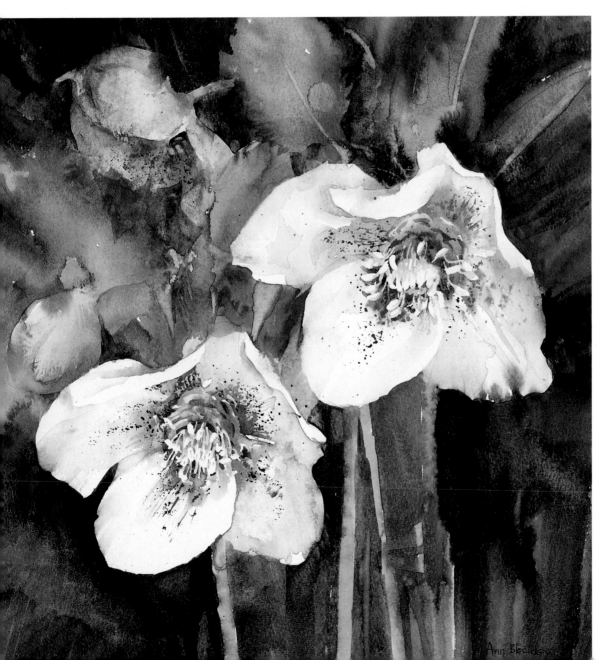

◁ Hellebore
35 × 36 cm (13¾ × 14¼ in)

The purple and greens of the background were inspired by the colours in the speckled markings and centres of the flowers. I used a combination of wet-into-wet, washing out and scraping techniques to develop a variety of edge values and textures in the background.

The character of flowers

It is often the petals that give a flower its character and they come in a huge array of shapes, colours and textures, from rounded and simple to jagged and frilly. Some are translucent, others are opaque; some have a velvety surface, while others are as shiny as shellac. To capture the essence of a flower it is vital to express these characteristics clearly with paint.

To keep flowers translucent, retain areas of very pale or dilute paint. Including hints of the background colour within the petals or in their shadows gives the idea that their transparency is such that the colour can be seen through them. Opaque or velvety flowers are better expressed with thicker, creamier paint. If petals are shiny, areas of white will lend a sheen. White petals are best left as clean and simple as possible.

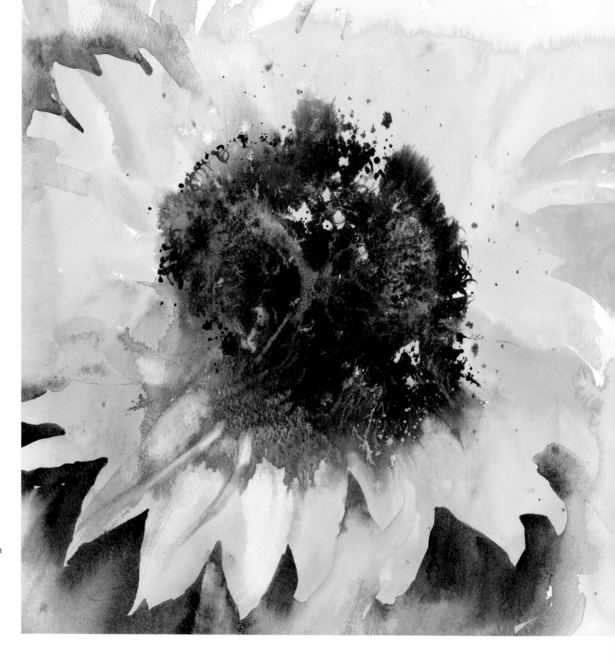

▷ The petals of this unfinished sunflower were largely developed out of a yellow background. My main interest was in the splashy centre. In real life this was a rigid, complicated and mathematical pattern, but I preferred to describe the texture very loosely.

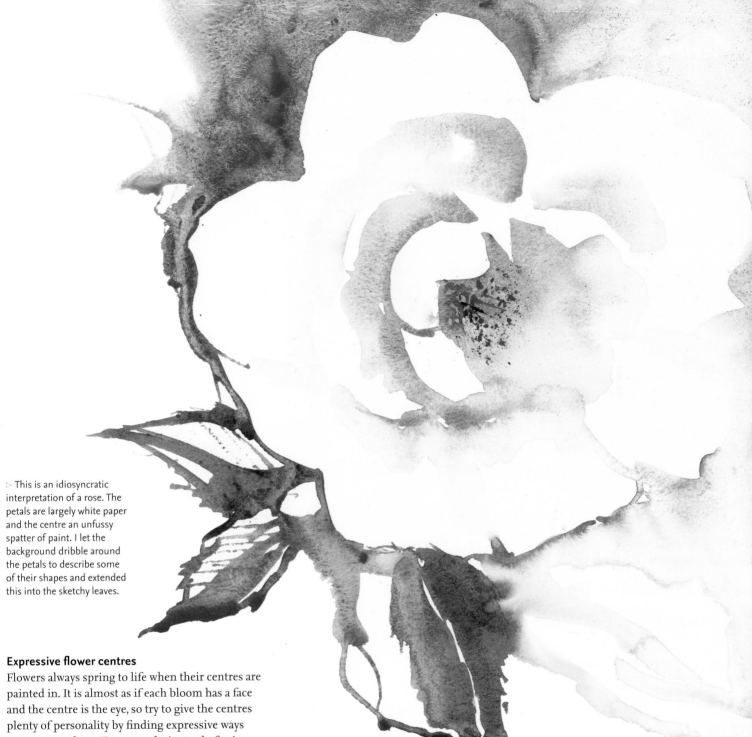

▷ This is an idiosyncratic interpretation of a rose. The petals are largely white paper and the centre an unfussy spatter of paint. I let the background dribble around the petals to describe some of their shapes and extended this into the sketchy leaves.

Expressive flower centres

Flowers always spring to life when their centres are painted in. It is almost as if each bloom has a face and the centre is the eye, so try to give the centres plenty of personality by finding expressive ways to represent them. For example, instead of using a small brush to paint in a series of dots, spatter a more random spray of specks using a palette knife. Stamens may be printed on with the palette knife edge to give them a textural quality.

The decisions you make about your markmaking techniques will depend on the distinguishing feature of the particular species; the centres should always look as if they belong to the flower, not as

if they are a separate addition. It helps to use soft-edged marks as well as hard-edged ones and to bring in colours that already appear elsewhere in the picture. To make the dark or brownish colour that appears in many flower centres, for example, combine several pigments from your established palette rather than introducing something new.

Spikes, stems and seedheads

Many of the textures and mark-making ideas described in this book are particularly relevant when you are painting plants that are prickly or spiky. Stems, twigs, winter skeletons, grasses and seedheads have different requirements to more flouncy, romantic flower pictures. Scraping, scratching and printing are just some of the methods suitable for these often hard-edged or complicated shapes.

Stems are frequently treated almost as an afterthought, but they can play an important part in a painting and they need to be planned. Ideally, you should try to vary them within a painting in order to create depth; soft edges will retire and the hard edges will come forward. Try printing some stems using the edge of a piece of cardboard dipped in paint, dragging it sideways to create a wider, broken-edged mark if necessary. You can chop the card into different lengths as required. Soft-edged stems can be achieved by working on a damp surface into which the paint will diffuse.

Pools of paint can be dribbled down the page to become meandering stems or dragged into spiky marks and tendrils with the wrong end of the brush or a sharp stick. To paint pale spikes, mask them with a fine pen nib or scrape them out of darker colour with a scalpel.

When you are painting fluffy or spiky seedheads, do not attempt to laboriously include every wisp or thorn. Use a few marks that represent the texture expressively and allow the viewer's imagination to form the rest of the structure.

△ **Thistles**
40 × 36 cm (15¾ × 14¼ in)

I painted these thistles on a mountboard surface treated with gesso. The brushmarks of the gesso showed through the subsequent washes to add movement, and it gave a non-absorbent surface that made it easy to scratch through the watercolour to describe the thistledown.

Explore further

- Practise painting spiky subjects and seedheads on various backgrounds using different methods. Smooth surfaces are often easier than rough ones for these subjects.
- Strong tonal contrast is often needed to show graphic subjects to their best advantage – try placing dark shapes on pale backgrounds and vice versa.

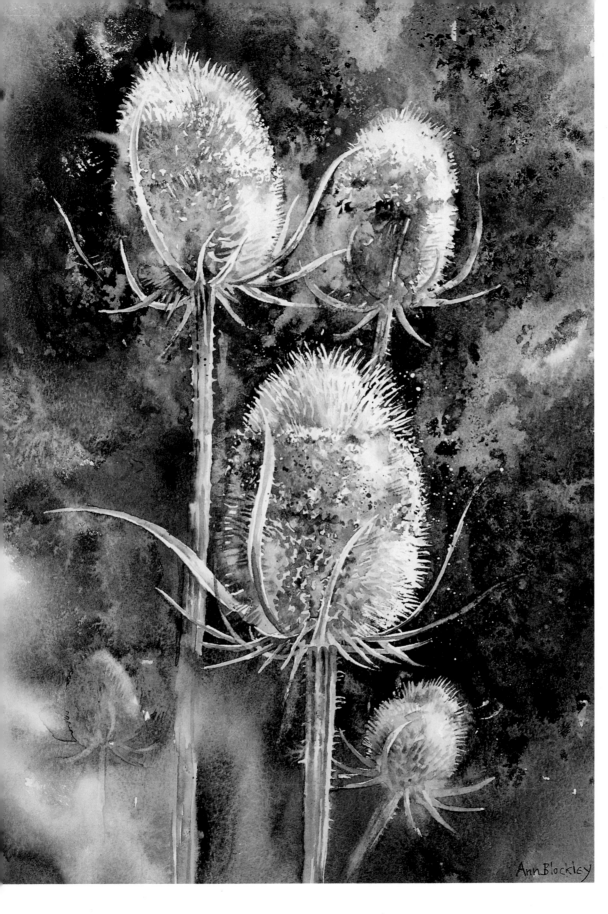

◁ **Spring Teazels**
37 × 24 cm (14½ × 9½ in)

I used masking fluid to block out the tendrils of the teazels. This allowed me greater freedom with the background texture, which was designed to subtly echo the mauve flowers.

Creating autumn leaf patterns

The infinite variety of leaf patterns provides a wonderful opportunity for playing with pigments and designing with shapes. Each individual leaf can vary tremendously in colour, texture and size. When their shapes overlap in groups to become new abstract configurations, or when different species of foliage are combined, the options increase endlessly; and in autumn, when the colours change and the leaves become weathered or curl into three-dimensional forms, you can turn to a new palette and different textural effects.

The fundamentally flat shapes of leaves are enhanced when combined with the rounded forms of berries; there is an interesting tension between the different surfaces of the shiny fruits and the textured autumn foliage. Almost any colour, medium or texture-making device could be used to describe a leaf pattern of some sort. The veins, the markings, and the endless choice of wrinkly, ridged, bristly or glossy surfaces are each fascinating maps of discovery. Forget the idea that leaves are a boring, green addition to a flower painting – they are an exciting subject in their own right.

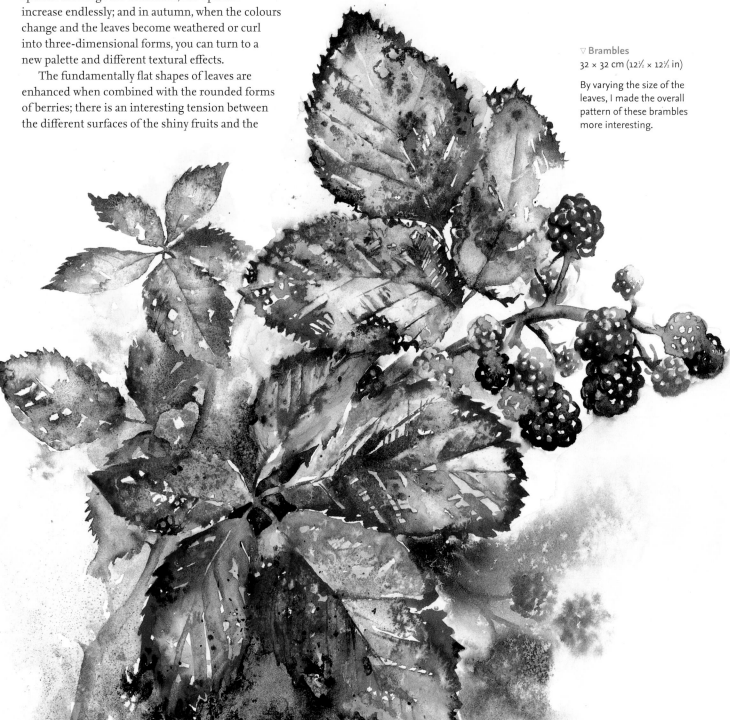

▽ **Brambles**
32 × 32 cm (12½ × 12½ in)

By varying the size of the leaves, I made the overall pattern of these brambles more interesting.

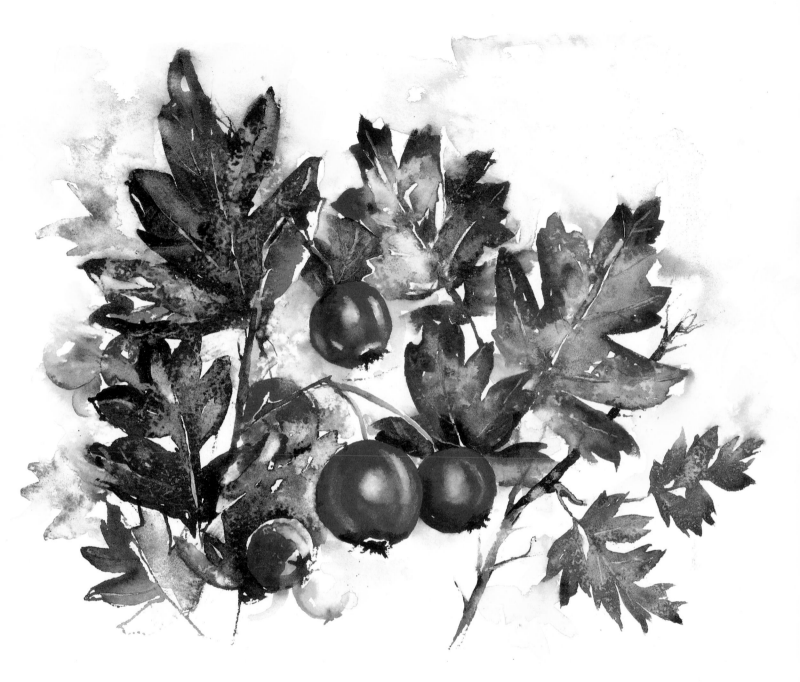

△ Hawthorn
24 × 32 cm (9½ × 12½ in)

I painted this much larger
than life – my berries were at
least four times bigger than
the real ones. This meant
that I had to exaggerate the
textures within the leaves.

Explore further

- Gather a selection of leaves and allow them to fall into
 a series of interesting random patterns of both positive
 and negative shapes. Make sketches of the different
 designs and choose one to turn into a watercolour.
- Create a collage by cutting or tearing leaf shapes out
 of tissue paper or any other material you have. Stick
 them onto board, using your chosen arrangement
 for reference. Cover the collage with gesso and then
 apply paint to create further leafy textures.

DEMONSTRATION Hogweed

This subject is a perennial favourite of mine – I never tire of painting the lacy effect of hogweed flowers. The hedgerow where these stems were growing was full of the movement of buzzing insects, scattered seeds, chasing shadows and a gentle breeze. I decided to build broken textures with salt and paint spatters to re-create this atmosphere.

Colours used
Cobalt Blue
Cobalt Violet
French Ultramarine
Indian Yellow
Sepia ink
White gouache

◁ Stage one

Stage one
Working on a surface of Saunders Waterford Not, I first used masking fluid to block out the intricate shapes of the main hogweed flower with all its tiny overlapping florets. I blocked out some details of a second flower and then spattered sprays of masking fluid with a palette knife around these areas to add shimmer. I was then free to paint loose wet-into-wet washes over the whole picture, using variations of all the colours I had decided upon. I kept the washes pale on the left to add light and concentrated the darks behind the flowers so that they would really sing out from the background. I flicked speckles of Sepia ink into the watercolour to add a little tone and sprinkled salt into the wet paint to develop pale mottled effects.

Stage two

I flicked and dribbled granulation medium into the washes and areas of ink to help separate the colour into grainy texture. I added more salt to the area above the main hogweed to increase its laciness and perhaps suggest the hint of further flowers. As the paint dried I blotted the salt and lifted out colour into broken textures. I used Sepia ink to begin indicating some stalks and the skeleton of a seedhead to help balance the composition.

◁ Stage two

Stage three

When parts of the wash were still damp but other areas were dry, I poured water gently into specific areas of the painting to loosen up the paint and rinse the damp parts of it away. This was useful for lightening up heavy areas and adding texture. I darkened the area underneath the main flower and continued painting the stems and seeds. I used the edge of a strip of watercolour paper to print paint into the linear markings of the stalks, dragging sideways to make wider marks and reprinting where necessary to achieve the ridged form of the main stem. When everything was dry I removed the masking fluid and rubbed off any remaining salt.

▷ Stage three

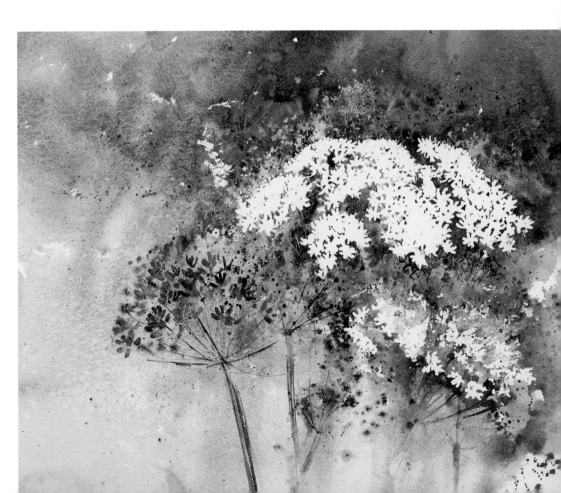

DEMONSTRATION

Stage four

I completed the hogweed flower by painting very pale, dilute green washes of French Ultramarine mixed with Indian Yellow. I broke up the overall shape into its more separate umbrellas of florets, spotted in some centres with a small brush and spattered some looser showers of dots with a palette knife. After finishing the stems, I added more detail to the still sparse seedhead. I used blue to pick out some negative petal shapes in the lower section of the picture in order to suggest another small flower. I then dotted paint into a distracting patch of white to the left of the big flower. This blended it into the rest of the broken textured washes. Finally, I spattered white gouache over the background surrounding the main subject to add further life and movement to the painting.

▷ Hogweed
34 × 40 cm (13½ × 15¼ in)

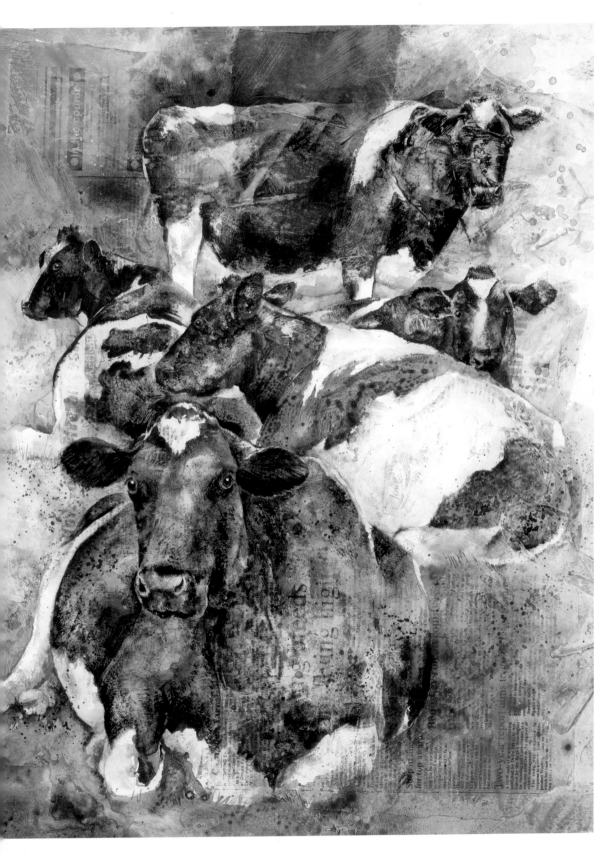

I tore pieces of newspaper into shapes that echoed those of patterns of Friesian cows and used them as a collage base, choosing articles from the farming section. I drew the shapes of the cows on top and used opaque gouache and translucent watercolour to develop them. The cattle were positioned to draw the eye through the painting, starting with the direct gaze of the large cow at the bottom and zigzagging up to the top.

DEMONSTRATION Ducks

These ducks were nestling in a marshy meadow, producing a wonderful contrast between the plain shapes of the bright white birds and the tapestry of textures that made up their resting place. I painted them on a mountboard surface prepared with gesso applied in random directions. This surface allowed me to lift, blot and scrape out colour to create a variety of textures.

Colours used
Cobalt Blue
French Ultramarine
Green Gold
Quinacridone Gold
White gouache

Stage one
I mixed creamy washes with combinations of all the watercolour pigments and painted them over the board, leaving some white in the area of the ducks. I placed the green mixtures in the foreground with the cooler blues behind to give a little sense of depth. The paint bubbled away from the gesso surface to create mottled textures.

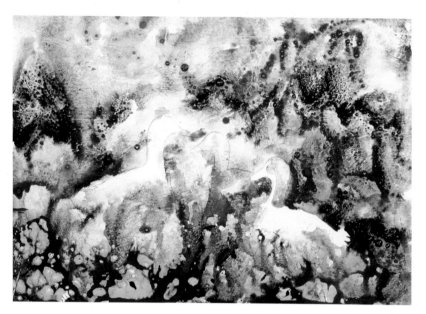

◁ Stage one

Stage two
Using the point of a scalpel, I scraped lines through the thickish damp paint to the white of the board in order to begin suggesting the grasses. In the same process some of the wet paint was also dragged into dark linear marks. I painted around the negative shape of the ducks to start bringing them out from the background, blotting out paint and adding more as appropriate.

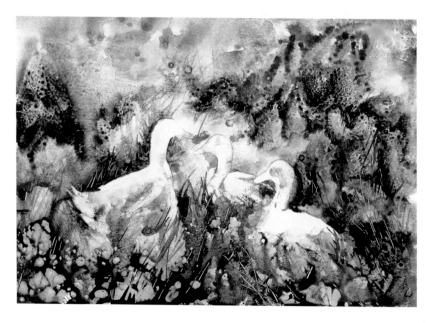

▷ Stage two

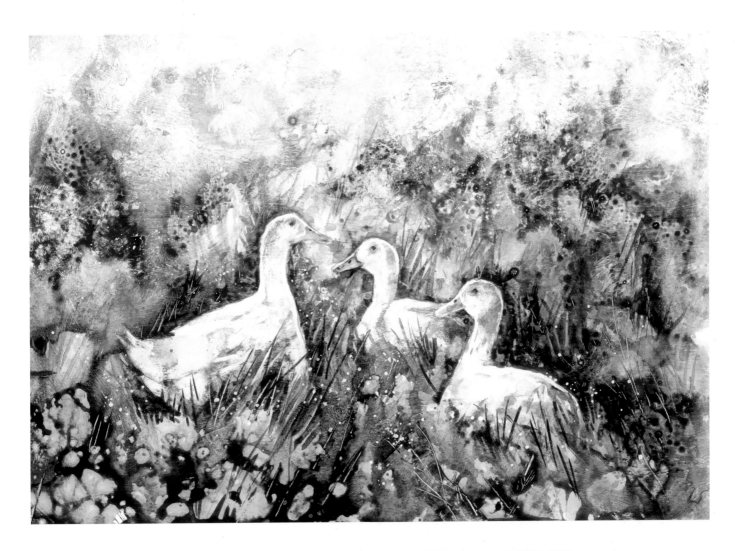

Stage three

The top area of the background was now dry, so I dampened it and blotted away some of the colour to even out the texture. I added shadows to build up the form of the birds and highlighted the edges with a little white gouache. I also strengthened some of the colour surrounding them in order to increase the contrast with the background. Dark grasses were painted around and overlapping the ducks to connect them with the ground where they sat. The beaks were painted in Quinacridone Gold and I added the finishing touches with details such as the eyes.

△ Ducks
21 × 33 cm (8¼ × 13 in)

◁ This detail shows how watercolour reacts on a mountboard surface. The non-absorbent gesso which is brushed on to prepare the board makes it difficult to apply a normal wash. Instead, the paint takes on a marbled texture which has a wonderfully tactile quality.

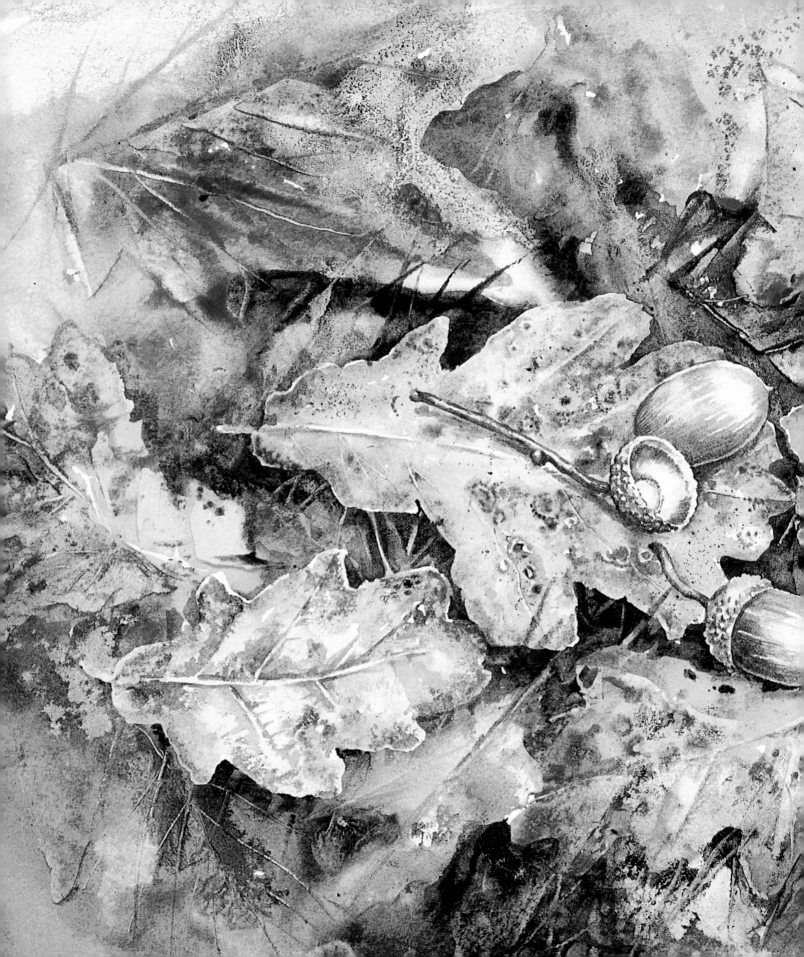

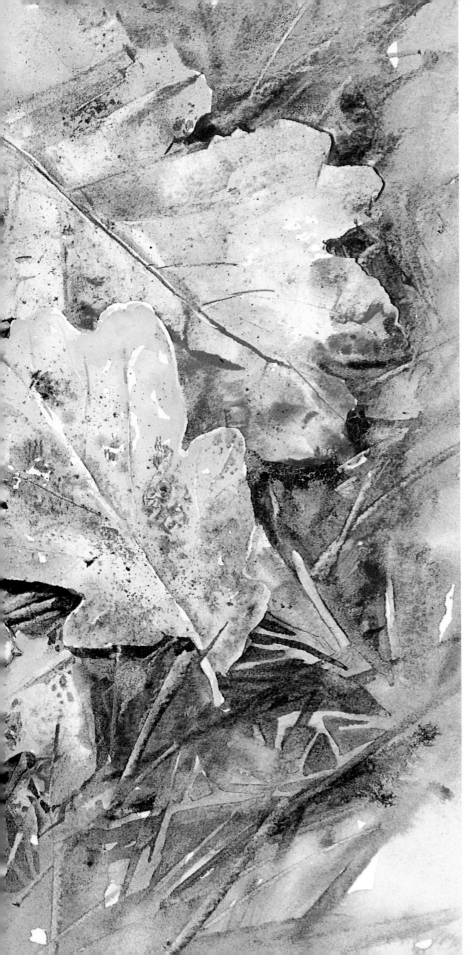

Still life

There is sometimes an assumption that a still life is a group of objects set up on a table. In fact, it could equally well be an arrangement of foliage on the ground, a variety of outdoor items such as gardening equipment or even larger objects such as chairs or even bicycles. Consequently, still lifes offer all sorts of chances to be inventive.

As your choice of subjects is so vast, you will discover that you need a wide repertoire of texture and pattern-making ideas to draw upon for this genre of painting. Explore ways to describe the surface textures and to experiment with design and pattern. You can create very decorative layouts with added borders or motifs; shapes can be chopped up, exaggerated, superimposed or enlarged. Look at the visual information you have gathered and feel free to interpret it in any way that you choose.

◁ Oak Leaves and Acorns
23 × 32 cm (9 × 12½ in)

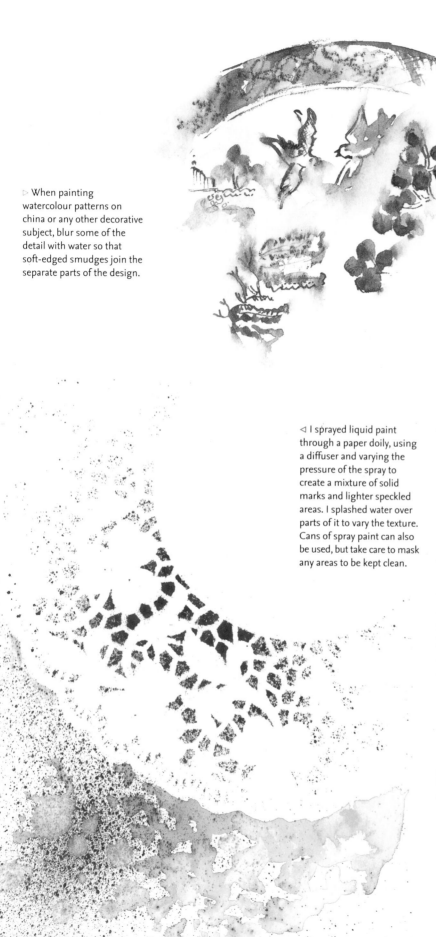

▷ When painting watercolour patterns on china or any other decorative subject, blur some of the detail with water so that soft-edged smudges join the separate parts of the design.

◁ I sprayed liquid paint through a paper doily, using a diffuser and varying the pressure of the spray to create a mixture of solid marks and lighter speckled areas. I splashed water over parts of it to vary the texture. Cans of spray paint can also be used, but take care to mask any areas to be kept clean.

Making links between subjects

When you are painting a still life there are usually various elements to be included, and these need to be linked in some way to create a unified picture. Each part should relate to the next in order to establish a cohesive whole.

These connections can sometimes be achieved through the use of colour – the red of a cherry might reflect in the blue china plate it sits on and the same pigments may be mixed and diluted to paint the tablecloth underneath. You can also choose subjects that echo each other in shape, form or texture, with cherries and plate both being shiny and rounded, for example. If you are painting a simple study of one object, the same criteria still apply; each part of the chosen subject needs to flow. A stalk should link with the fruit and sit happily on its background.

Paint the elements of your still life loosely, making shapes merge by keeping some edges soft and letting colours flow between neighbouring items. Children like their paintings to be tidy, with lines drawn around the edges to keep each section or colour separate, but adult painters can give themselves permission to break the boundaries.

Explore further

- Paint a subject or series of objects and when they are still slightly damp drop a little water into each shape. Mini back runs and dribbles will flow between separate colours and areas, loosening and linking them.

△ A still life subject can be a large, complex arrangement of varied objects but sometimes a simple, small subject makes a refreshing change.

Painting lace

Lace is inextricably linked with the surface it lies on, since glimpses of it show through the gaps between the fabric. The two elements may be linked by using paler versions of the background colour to form the shadows on the lace. It helps if some of the lace edges melt away in places. Small wet-into-wet washes will create soft edges and details may be drawn in with watercolour or graphite pencils.

Keep the details in lace or any other fabric to a minimum. It is not necessary to painstakingly spell out each little hole, stitch or pattern; subtle hints will be sufficient.

▽ Cherries on a plate
21 × 26 cm (8¼ × 10¼ in)

There are many factors that link the elements of this painting together, but there is contrast too in the square corner of lace which borders the other circular shapes. The shine on the cherries was achieved by leaving hard-edged patches of white paper.

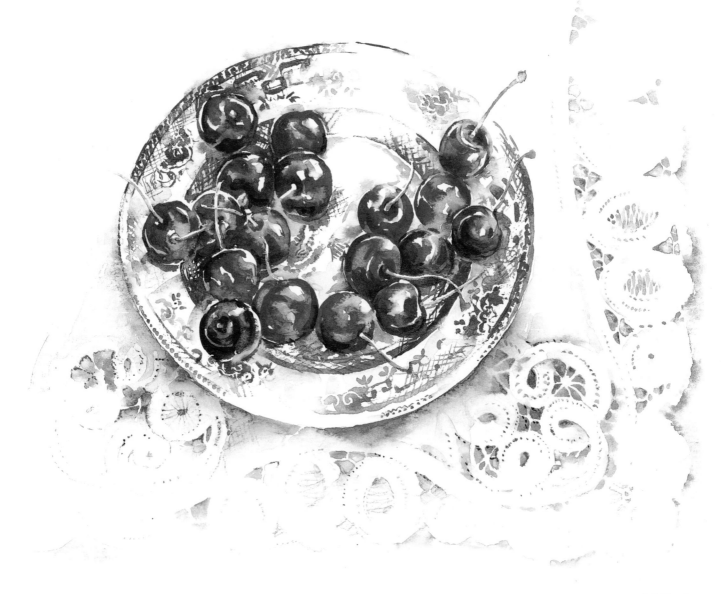

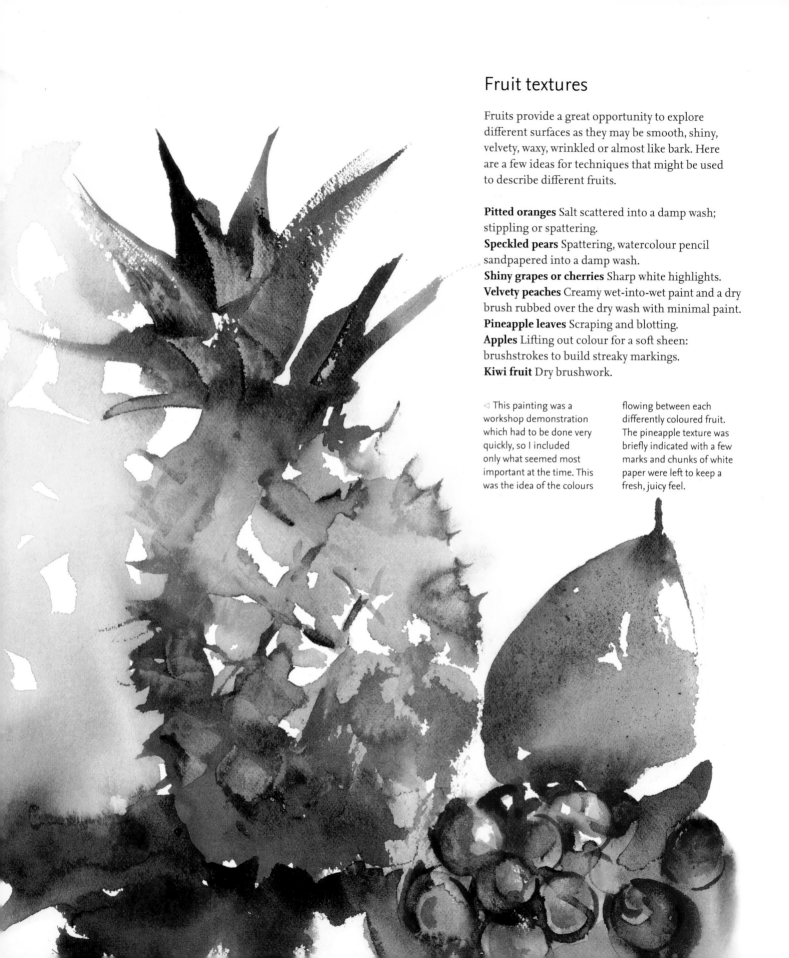

Fruit textures

Fruits provide a great opportunity to explore different surfaces as they may be smooth, shiny, velvety, waxy, wrinkled or almost like bark. Here are a few ideas for techniques that might be used to describe different fruits.

Pitted oranges Salt scattered into a damp wash; stippling or spattering.
Speckled pears Spattering, watercolour pencil sandpapered into a damp wash.
Shiny grapes or cherries Sharp white highlights.
Velvety peaches Creamy wet-into-wet paint and a dry brush rubbed over the dry wash with minimal paint.
Pineapple leaves Scraping and blotting.
Apples Lifting out colour for a soft sheen: brushstrokes to build streaky markings.
Kiwi fruit Dry brushwork.

◁ This painting was a workshop demonstration which had to be done very quickly, so I included only what seemed most important at the time. This was the idea of the colours flowing between each differently coloured fruit. The pineapple texture was briefly indicated with a few marks and chunks of white paper were left to keep a fresh, juicy feel.

Form and detail

It is easy to become so involved in the superficial surface textures that the basic form gets forgotten. All fruits are three-dimensional objects and the best way to describe this solidity is through tonal values. It is helpful if the fruit is illuminated on one side, leaving the other in shade; the shadows also help to highlight bumpy textures and the light emphasizes shine.

When there is a complicated combination of texture and shapes it is tempting to concentrate hard on each element of the picture. There are no rules dictating how much detail to include; this is a personal decision, but it should be a considered choice as it will play a major role in the style of the painting.

When I first began to paint I described as much detail as possible, using a very fine brush. The result was almost photographic. Now my style has greatly relaxed. I try to capture the essence or character of my subject, being selective about which information to include and leaving a lot to the imagination.

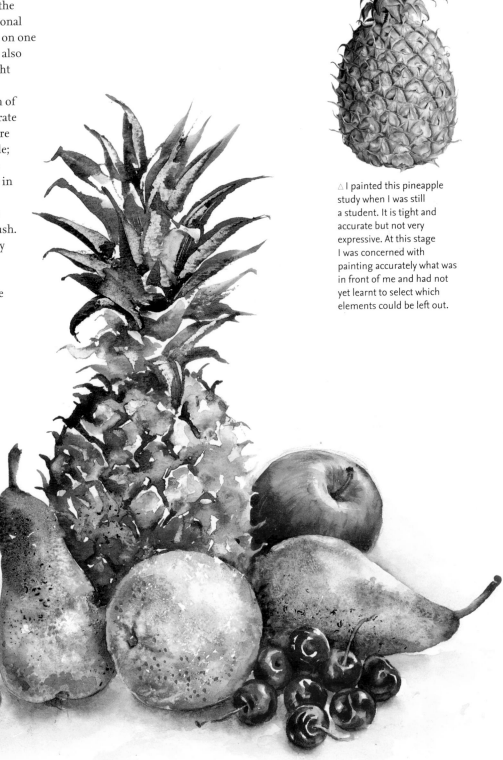

▷ **Fruit**
29 × 29 cm (11¼ × 11¼ in)

This fruit still life was painted in a more relaxed time scale and I was able to draw the shapes more carefully and describe the different fruits quite accurately. However, a lot of detail has been left out and some of the textures, especially in the pineapple, are quite loosely painted.

△ I painted this pineapple study when I was still a student. It is tight and accurate but not very expressive. At this stage I was concerned with painting accurately what was in front of me and had not yet learnt to select which elements could be left out.

PROJECT Combining shapes and patterns

When you are choosing the elements of your still life paintings, combine different objects in a variety of shapes and sizes but try to relate them to each other in some way. Too many competing types made from diverse materials could be visually messy unless they have at least something in common such as a similar shape, colour or texture.

When you have made your choice, move the objects around and view them from all angles, above and below, in order to find the most interesting distribution of shapes. If you raise your subject or put it on the floor it creates a new perspective which can be a refreshing change from the usual eye-level arrangement.

Choosing the backdrop

If you are painting a backdrop to your still life, remember this should also relate to or enhance the main subject. This could be in terms of colour or theme. Ethnic pots might look good against an oriental textile, for example, whereas rustic subjects may sit better on a wooden surface or country-style fabric. Try as many types of background as you can find, such as tablecloths, curtains, patchwork, large platters or trays, rugs, gift wrap, wallpaper or perhaps a collection of different patterns.

The next step is to find methods of representing their patterns or textures. Try printing and mark-marking, using different tools. Do not attempt to stick too rigidly to the pattern. You can lose edges and fade the marks away in places by blotting, using graded washes or washing out. This type of 'lost and found' paintwork where the details and edges appear and disappear is far more stimulating than a photographic approach and can help direct the eye around the picture.

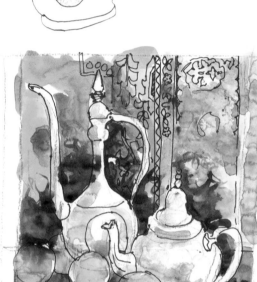

△ When he was eight, my son made these line drawings of oriental pots. I love the higgledy piggledy distortions of the already interesting shapes and the way certain patterns have been selected and carefully drawn in detail. Try to look at subjects through a child's eye to inject character into your pictures.

▷ This is a preliminary sketch for *Oriental Pots*. The fruit echoes the rounded pots, but I excluded it from the finished painting as I decided to concentrate on the textile patterns in the background. Play with ideas in this way before committing yourself to the finished painting.

◁ Detail from *Oriental Pots*. Although the chosen textile had a very formal pattern I chose techniques which broke down the rigid edges and created a loose texture.

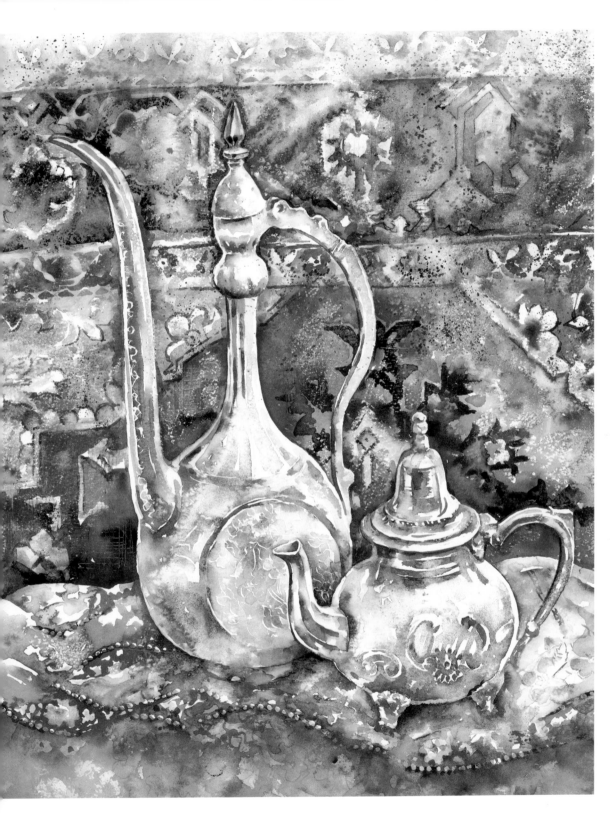

◁ Oriental Pots
45 × 39 cm (18 × 15½ in)

The pale patterns on the
metal pots were drawn in
with masking fluid and left
white to keep them shiny.
Candle wax was rubbed
into the background to leave
a broken texture which
helped to describe the
woven rug. Salt added to the
washes and splatter applied
afterwards also contributed
to this effect.

Tonal values

The background should be planned as an integral part of a still life. Paintings can look wonderful on a white or empty background, but that decision needs to be made at the very beginning as the tonal value of such a background has a huge impact on the picture and the order in which it can be painted. It is a good idea to view your subjects against both pale and dark backdrops before you make your choice.

Where traditional watercolour is used on white paper you will need to reserve or lift out the pale areas; if using gouache or acrylic, you can put in the darks first and add lighter colours on top later.

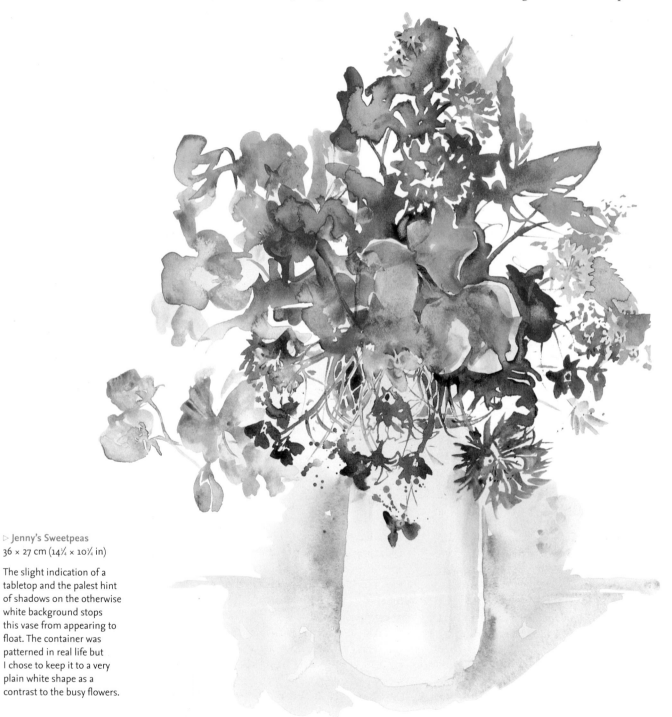

▷ Jenny's Sweetpeas
36 × 27 cm (14¼ × 10¼ in)

The slight indication of a tabletop and the palest hint of shadows on the otherwise white background stops this vase from appearing to float. The container was patterned in real life but I chose to keep it to a very plain white shape as a contrast to the busy flowers.

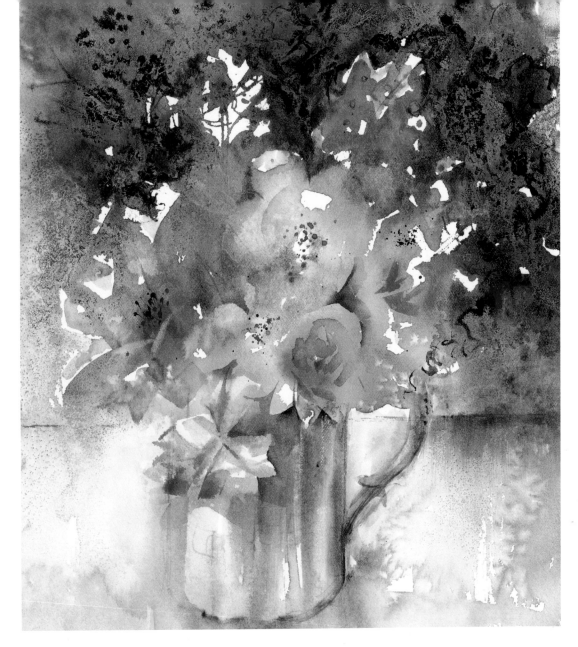

28 × 24 cm (11 × 9⅜ in)

Ink was added on top of wet watercolour in this dark background and the paper gently tilted to move the pigment into textures. Flickers of white were left in order to keep the sparkle. The white vase was painted partially dark against the light foreground to help balance the picture.

Large areas of light and dark

A large area of dark colour in a painting can easily become heavy or muddy, but relieving the tone in some way will help to prevent this occurring. One method that will have the effect of injecting more life into the dark area is to choose a variety of colour mixes. This does not necessarily mean dramatic leaps from one mixture to another; even subtle movement within a dark hue will help to make it sing.

Vignettes that are painted on white paper can be given a little atmosphere with hints or smudges of colour in the background. A degree of tone is especially useful placed around pale shapes to help bring them out from the white behind them.

Adding texture

Dribbling granulation medium through the wet area or spattering with a lighter opaque colour on top of the dry wash can help to break up strong tones. Try using a medium tone then splashing inks or dark paint into the wet wash to strengthen it.

Light areas may need more interest than a simple wash can provide. Scattering salt into a wet wash creates a very subtle texture. Dropping water into a pale wash as it dries and repeating the process until a light marbling is built up can also be effective.

▷ A dark swirl of paint and a curving line of ink are all that indicate the edge of the jug and its handle. The flowers are a crazy blur of colour and texture. I would love to develop this further – the challenge would be in not destroying its spontaneity.

Developing a personal style

Just as everyone has their own unique personality, each painter should have an individual style that reflects their own particular way of looking at the subject. The personality of the picture will be influenced by the type of marks and textures that are applied.

You will have developed your own handwriting and signature without too much thought, and the same thing will happen with your painting if you practise enough. At first you may feel self-conscious as you try different ways of making marks, but it is natural to follow other artists' methods and styles, combining ideas from different people until eventually your own preferences take over.

Simplifying containers

On one of my workshops I presented the students with huge jugs filled with a cottage garden collection of flowers – a daunting task if they were to paint the whole subject realistically. I allowed them to look at the arrangements for a few minutes then removed them from view. The idea was to capture an expressive impression of the still life by remembering colour combinations and the general movement of the shapes; flowing colour and descriptive texture-making methods were to be used.

The results that the students produced were stunning and individual. The absence of the vases to analyse for detail made the paintings loose and uninhibited. The experiment forced the students to be very selective and the feel of the subject was created through remembered abstract qualities rather than individual features. A white vase was pared down to a simple bare shape; complicated structures were suggested with some sweeping linear drawing. Patterns and decorations were indicated with a few brushstrokes, some printmaking or clingfilm textures.

Working in a free or loose fashion such as this tends to result in more expressive work. You will probably find that the subject usually dictates the techniques or colours you choose.

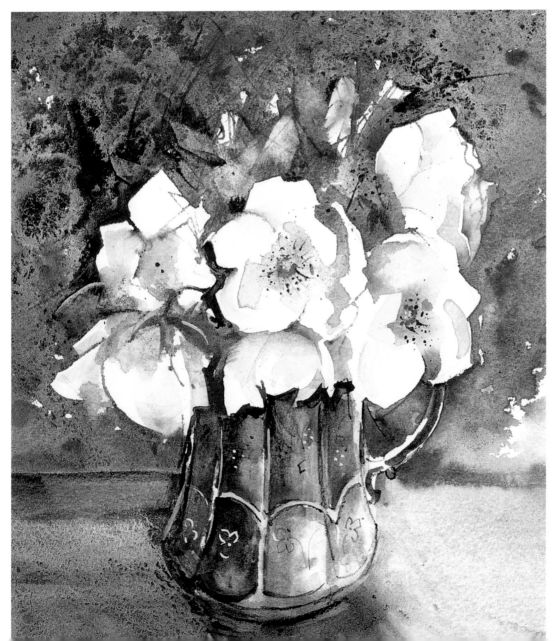

◁ White Roses on Blue
27 × 24 cm (10½ × 9½ in)

The graphic, angular shapes of the roses contrast with the textures in the background. The jug was quite a complicated design but I simplified it to suit the stylized theme. The limited palette helps to create a mood.

GUEST ARTIST
John Blockley PPPS RI RWA NEAC

John Blockley was a very highly regarded artist. He was a member of the Royal Institute of Painters in Water Colours, the New English Art Club and the Royal West of England Academy, and was a Past President of the Pastel Society UK. His books on painting techniques have become collector's items and his paintings are in collections worldwide.

John Blockley was an experimental and progressive painter who caught the mood and sense of what he was painting rather than making a literal interpretation. He was not interested in the idea of setting up a formal still life, preferring to paint things as they occurred. Any arrangement would be done by emphasizing some parts and subduing others until he had created a design with which he was visually satisfied. It was not that he ignored what was in front of him; the process was one where he exaggerated certain areas and sharpened or softened edges to attract attention or reduce their impact.

John looked at the world with a painter's eye and saw it in abstract terms of colour, texture, shapes and edge values, then played with these qualities on paper in order to capture his reaction to a subject. If he painted a vase of iris the aim was not to draw the exact botanical form but to describe a series of sharp edges, powerful shapes and exciting relationships of colour. He often exaggerated the negative spaces as much as the positive areas and used the empty spaces of the backgrounds as an opportunity to experiment with textures. Such areas were sometimes pale, subtle and sensitive; paint was washed out, dragged or lightly mottled to gently break up large washes. At other times he used more dramatic texture with strong tonal or colour contrast. He combined different mediums and experimented endlessly with paint in order to express his ideas.

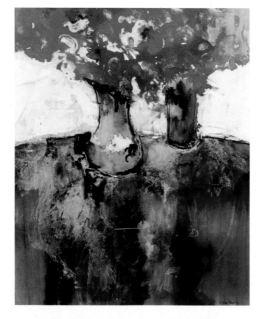

◁ Red, White and Blue
53 × 43 cm (21 × 17 in)

John constantly experimented with and combined different mediums in order to achieve a particular texture or edge value. This painting began with ink and watercolour but pastel has been drawn and smudged on top.

▽ Detail from *Flowers and Fruit*. The simple, abstract forms of the fruit are a contrast to the textural background. There is no need for detail as the strong colours tell the story.

△ **Flowers and Fruit**
34 × 37 cm (13½ × 14½ in)

The orange shapes sing out from the contrasting darker textures of the background. The crimson flowers are set against another warm red and are therefore less dominant. A combination of ink and acrylic paint has been used to achieve the vibrant colours and the paint has been manipulated and pushed around to build the patterned texture of the backdrop.

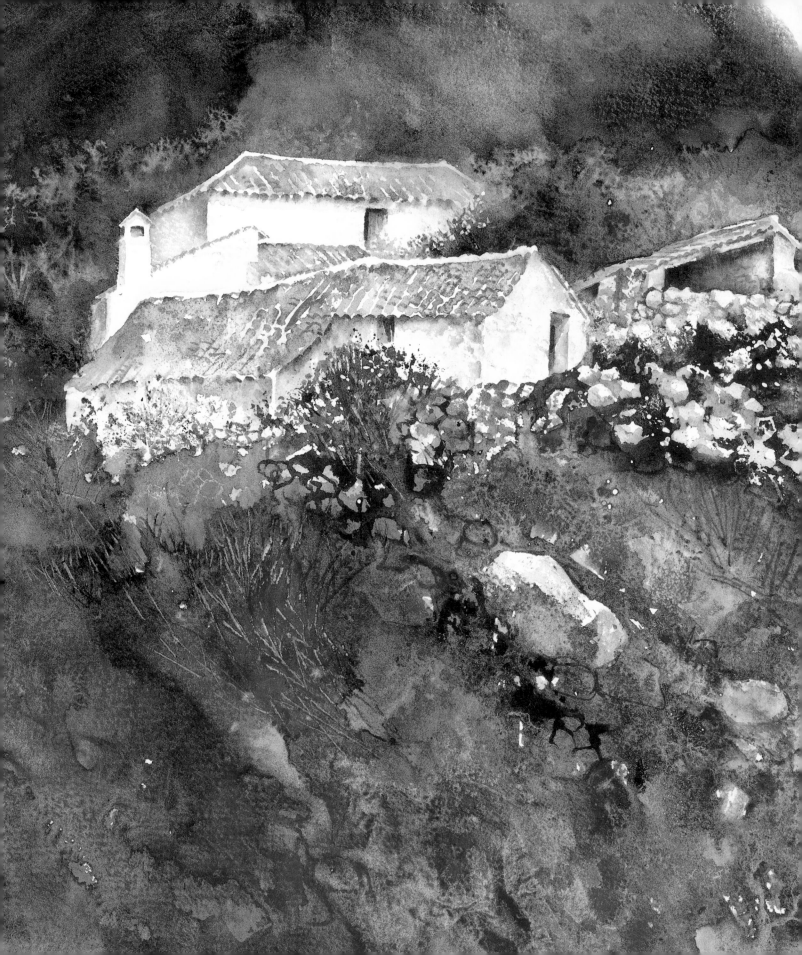

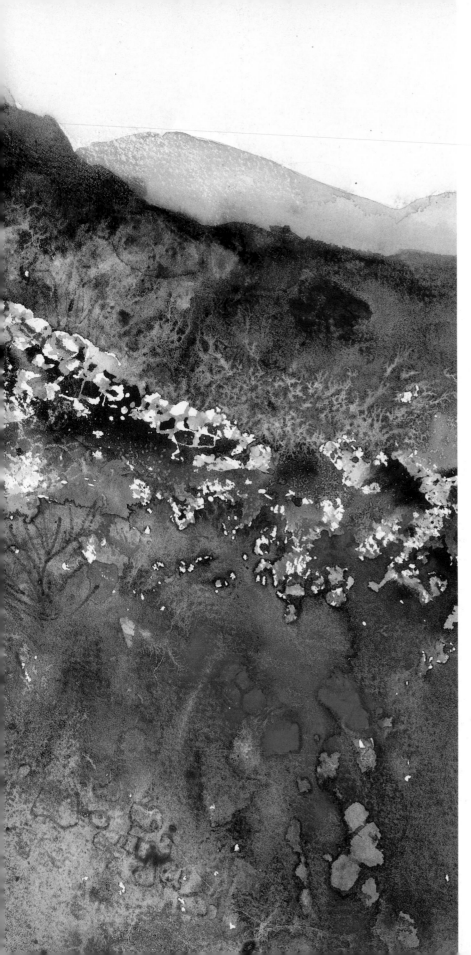

Buildings

Buildings provide fantastic scope for an artist wanting to play with texture. The materials that are used to make walls, roofs and doorways all have very tactile, textural surfaces, especially when they are weathered or ancient. Lichen-covered stone, crumbling bricks, distressed paint and flaking woodwork are all perfect opportunities for paint explorations.

The textures within walls, windows and architectural details can be quite dramatic when they are examined at close quarters. Viewed from a distance, however, they become less specific, and the overall context of the building and its surroundings takes over. The way that buildings relate to the landscape around them is fascinating. They are very often built from local materials and this gives a visual connection, a rightness that is tremendously satisfying.

◁ Andalucian Farmstead
28 × 34 cm (11 × 13½ in)

Simplifying buildings

Buildings are usually constructed from a variety of different materials, and the brickwork of a single wall may vary in colour and texture. Consequently, buildings are very complicated subjects, but as artists we have the choice to simplify them. For example, instead of studying the crumbliness of each individual brick, we can look for the overall patterns and general impact of the wall.

When you are painting a section of a building in close up there is a particular temptation to attempt to include everything. However, it is more effective to paint washes over whole areas and just pick out details here and there, softening and blotting the edges to help them gradually disappear. You will find it looks more meaningful if the parts you choose for detailing are contained within specific areas rather than being distributed evenly throughout a picture. These areas can play a part in the composition of the picture, leading the eye to a prominent feature – for example a few stones painted around a central doorway instead of around the perimeters of the design.

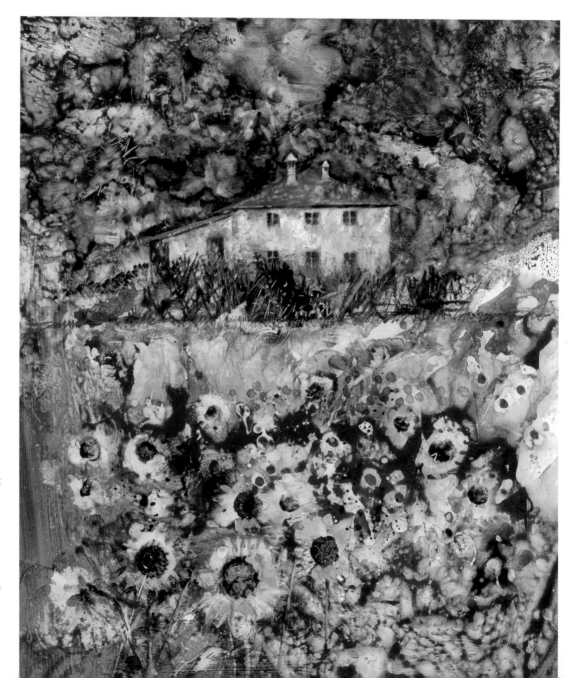

▷ Tuscan Sunflowers
29 × 21 cm (11½ × 8¼ in)

I painted a background over the whole surface, creating texture to suggest a foreground of sunflowers and a verdant backdrop. The house was then painted on top in gouache, softening and blotting each layer so that elements of the underpainting showed through, linking building with background. Detail was kept to a minimum to maximize the contrast between simple house shape and textured landscape.

▽ North Wales 1
26 × 33 cm (10¼ × 13 in)

The lively and sketchy spontaneity of this watercolour, painted very quickly on paper, is deceptive as I only achieved this after several practice runs. Texture here is subtle and secondary to the overall colour and tonal patterns.

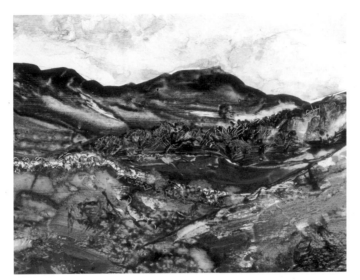

◁ North Wales 2
15 × 20 cm (6 × 8 in)

This is the same scene as *North Wales 1*, but this time I worked on board. The paint settled itself into a mottled texture which I scratched and drew into to develop the wall and distant hedgerow.

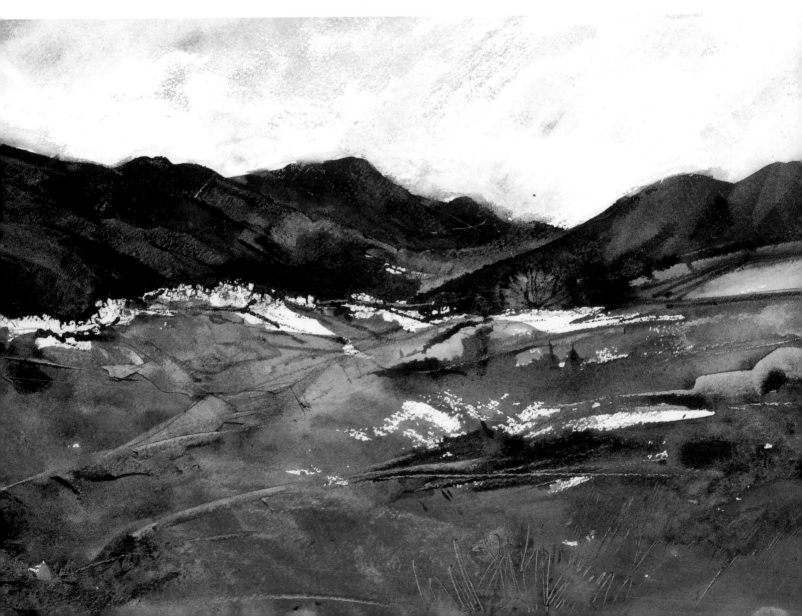

Textures in water

▽ Coast
18 × 24 cm (7 × 9½ in)

This coastal seascape was painted on a board prepared with gesso. The slippery surface made it easy to scrape pigment out of the streaky washes with the flat edge of a knife. Paint had gathered in the brushmarks of the gesso to add a sort of stormy movement to the picture.

Stormy seas, rushing rivers, meandering streams and the sparkling spray of waterfalls all demand different texture-making treatment. Water effects are largely dependent on the way the light falls and how disturbed the surface is as a result of the degree of movement in it. Calm water is easily indicated with a simple graded wash. The minute a ripple appears, you will need to lift out paler streaks or add darker ones. Sometimes these will be hard-edged, other times softer marks do the trick.

To produce convincing sparkles, prepare the surface with a spattering of masking fluid or some candle wax rubbings. Working on Rough paper also leaves appropriate speckles of white. Scratching and scraping off paint leaves hard-edged riffles, while lifting out paint creates gentler waves. Spray and foam effects can be made by spattering white gouache on top of a wash.

Basically, when you are painting any sort of water, you will find that virtually all techniques will be useful that develop a pale mark out of a darker wash or leave white paper.

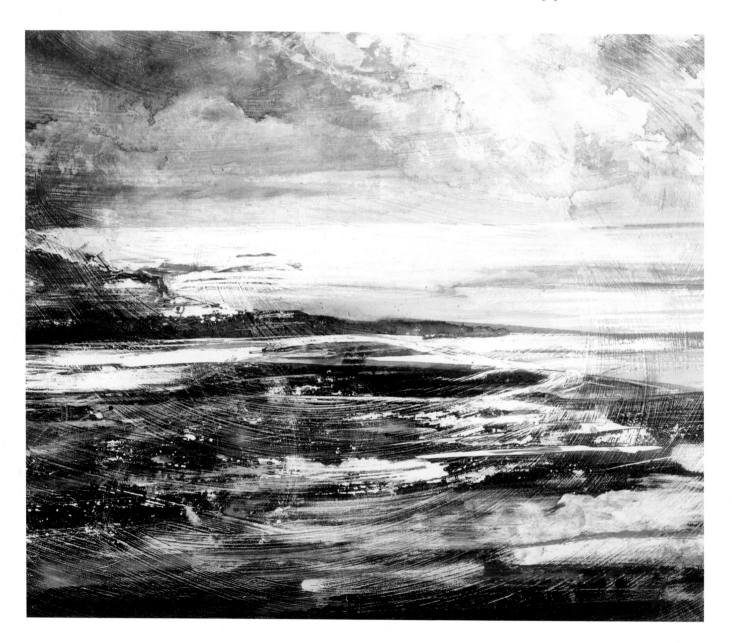

◁ I used candle wax first but then scraped paint out of the wash with a blade. I also spattered white gouache into the damp paint to make further shimmery effects.

Reflections

Reflections play a large part in the depiction of water. They may be soft-edged and vague or crisp and definite, again according to light and movement. Still water can reproduce a perfect mirror image, but the merest ruffle upon the surface disturbs the reflection into abstract patterns. Such marks are best indicated with softer edges than you have used to paint the subject that is reflected so that they are less dominant. The easiest way to achieve this is by painting the relevant shapes or lines into a damp wash.

Decisive brushwork is called for when you are painting water. Marks need to be either crisp or soft, but not woolly.

△ Candle wax was firmly applied to Not paper and a wash brushed on top to create this sparkly water.

◁ Creamy paint was brushed lightly over the raised tooth of the paper where I wanted white speckles to show through. A white oil pastel on top of a dark, dry wash would achieve a similar effect.

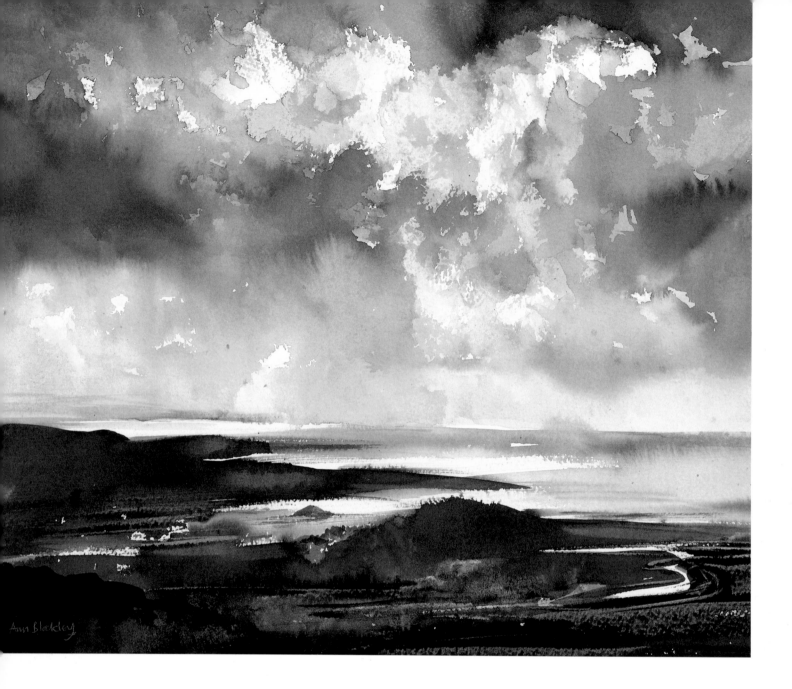

△ **Impending Storm**
29 × 41 cm (11⅓ × 16¼ in)

Vigorous, ragged-edged white shapes were left within a wet-into-wet watercolour wash. I used Indigo with a tiny touch of Cadmium Red to create moody darks, then blended in some very dilute Raw Sienna at the horizon. Streaks of white paper were left to suggest light on the coastal water.

Painting skies

Skies are a fantastic subject for any artist as they contain a never-ending variety of shading and texture. For anyone wanting to practise watercolour techniques in particular, they offer endless opportunities for paint exercises. Wet-into-wet washes are the ideal method for beginning many skies; they can be played around with, broken up, lifted and blotted to create cloud formations. Traditional flat or graded washes are perfect for cloud-free skies. Sprinkling water or salt into washes will produce weather effects such as rain or snow, and leaving white paper within the wash will show where sunlight floods or glimmers through.

Painting clouds

Brushwork and broken effects can be used to describe the many different types of cloud formations. Edge values play a vital role. It is easy to think of clouds as gentle, fluffy things to be blotted out of washes with soft brushes or tissues. However, sometimes surprisingly sharp, geometric shapes can be seen in clouds and edges are very

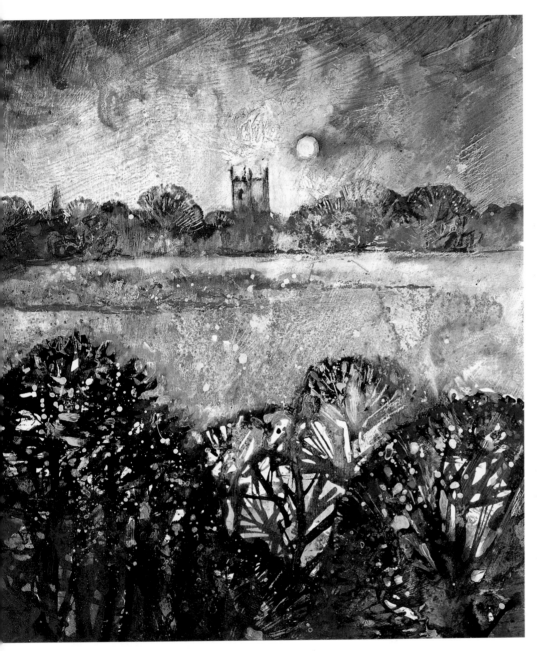

△ Church View
17 × 17 cm (6¾ × 6¾ in)

In another version,
a section of which is shown
here, I changed all the
colours to autumnal yellows
and browns, echoing
the warm colours in the
sunset-flushed sky.

◁ Stow on the Wold
by Moonlight
20 × 18 cm (8 × 7 in)

In this moonlit wintry
interpretation the trees have
been painted in such a way
that their identity is merely
a suggestion. This lack of
solid information imparts a
mysterious, fairy-tale quality.

Simplifying a busy landscape

There are many elements and details in any
landscape that do not necessarily need to be part
of the painting. If you include every hedge, wall
or slight change in the contour of the land, the
result could be a composition that is too busy.
It is better to be selective and include only those
features that add something to the design. You may
choose to bring trees closer together, eliminate

certain misplaced rocks or simplify groups of
overlapping buildings.

Wherever possible, try to see any series of
subjects as simplified groups rather than separate
items. Often a painting will seem more cohesive
if such collections of shapes are all painted in the
same colour or tone without the details and
variations that can be seen in real life. The elements
you decide to leave out help towards the creation
of an expressive and individual interpretation.

DEMONSTRATION Cottage in the Hills

I saw this mountain cottage on a trek in North Wales. I made a rough sketch with notes to record my impressions of the colours and textures then, in my studio, created a painting based more on memory than fact. This approach gave me the freedom to interpret the textures of the rugged terrain in an imaginative way that tries to capture the mood of the scene.

Colours used
Coeruleum
French Ultramarine
Raw Umber
Sepia ink

Stage one
I painted around the basic cottage shape on watercolour paper, using washes of all the colours to indicate the different areas and leaving spaces to indicate some rocks. I added ink to the mountain and foreground and while this was wet I dripped in granulation medium to create texture. I defined the rocks with a little ink drawing.

◁ Stage one

Stage two
When the initial washes were dry I used Coeruleum to paint the sky and define the edge of the distant mountain. The central strip needed attention, so I added more ink and granulation medium to give texture. I dampened the area behind the building and drew some vague trees with a black watercolour pencil. I used an ordinary pencil to draw the structure of the cottage.

▷ Stage two

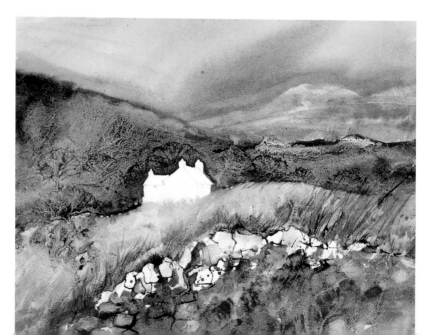

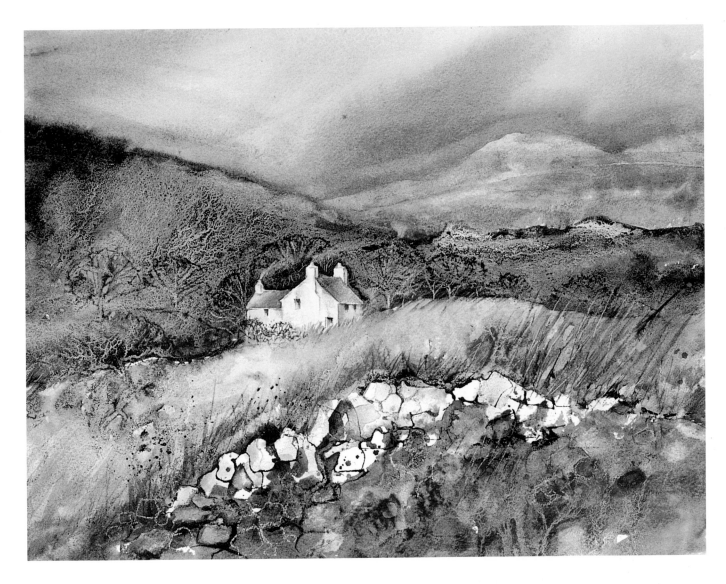

Stage three

I completed the picture by filling in the details of the cottage. I chose a grey mixture from my palette to paint the dark roof and windows, then diluted it to add the shadows of the white walls. I used a white Conté pencil to smudge a drift of smoke from the chimney and draw some stones in the foreground. Finally, with a black watercolour pencil, I suggested some grasses and further details.

△ Cottage in the Hills
28 × 38 cm (11 × 15 in)

◁ This detail shows how the granulation medium has been allowed to dribble through and break up the ink and watercolour into rivulets of grainy texture. I tilted the paper to allow the wet mediums to move downwards in the direction that I chose.

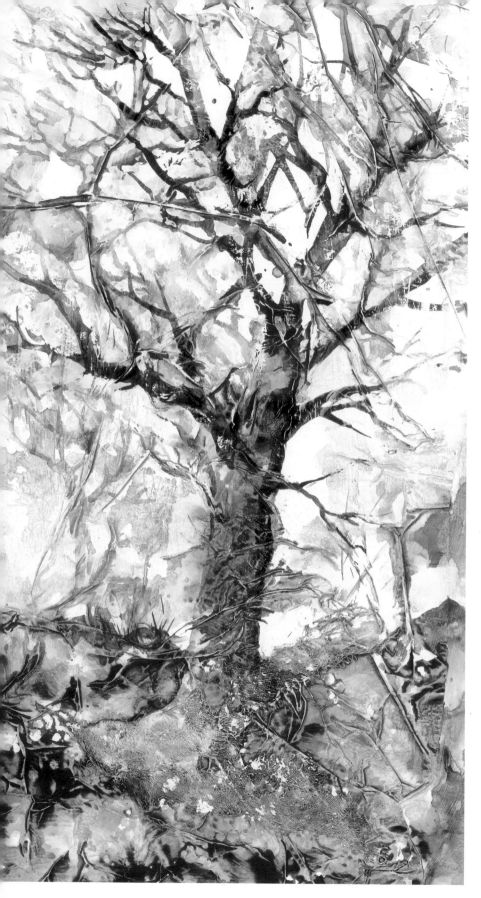

The textures of trees

There are many aspects to trees that make them ideal subjects for texture-making. The different types of bark – flaking, ridged, smooth, speckled and so on – all demand diverse painting techniques.

Painting mottled bark with washes then disturbing them by blotting bits out or adding granulation medium, ink or water works well. For heavy textures, use thick paint and scrape pieces out. Using a flat-edged brush or piece of card to drag paint sideways in a series of overlapping marks creates another type of bark surface.

◁ Winter Tree
28 × 16 cm (11 × 6¼ in)

This tree scene was painted on a base of tissue paper which crumpled into folds when applied with PVA glue to a mountboard base then covered with gesso. The paint ran down the ridges of the collage base to create branch-like linear effects and a blotchy foreground.

▽ Detail from *Winter Tree*. In this section I stuck torn lace into the foreground area and added further textural interest at the bottom of the tree.

Seasonal trees

The foliage of trees varies according to the time of year as well as the species. In spring and autumn, gaps show between the leaves but during the summer the leaf masses become increasingly solid. For sparse foliage patterns, try painting broken washes then spatter and splash more paint on top while they are still damp to make soft splodges. Repeat when they are dry for firmer marks. The uninterrupted leaf patterns of summer are better simplified and treated as jagged shapes and larger areas of colour.

In winter the branches become the main feature and you can use a full range of brushwork. For a spontaneous approach, start the branches with generous splashes of dark paint then allow the excess to dribble around the picture by tilting the paper and directing the paint into appropriate patterns. Where there are little pools of colour, blowing on them will make the paint shoot out into perfectly formed twiggy marks.

Planting your trees

Your trees must appear to be firmly planted into the ground out of which they are growing. You can achieve this in the same way as you would treat buildings or any other subject built or placed onto a base; allow the tree, house, flower or vase to flow, uninterrupted by hard edges, into the surface on which it lies. Even when there is a clear delineation between the two, blend the colour of a tree trunk softly into the pigments within the foreground. The two areas then seem naturally linked.

Fun can be had with the ground itself beneath trees, where you can usually see a wide variety of textures. Boulders, undergrowth, fallen leaves and grasses all help to anchor trees and give them a sense of place.

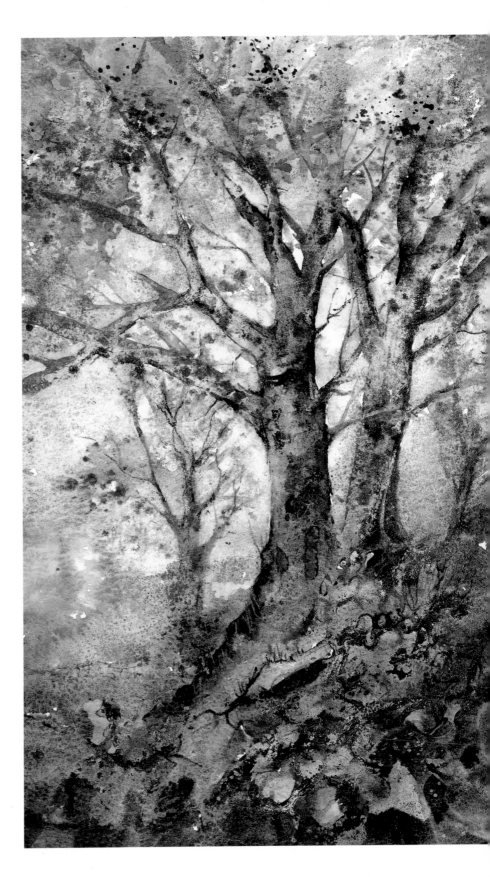

▷ Woodland
25 × 17 cm (10 × 6¾ in)

This was painted on watercolour paper with watercolour and Sepia and Indian ink. Granulation medium was dribbled into the washes to create broken marks in the bark and stony foreground.

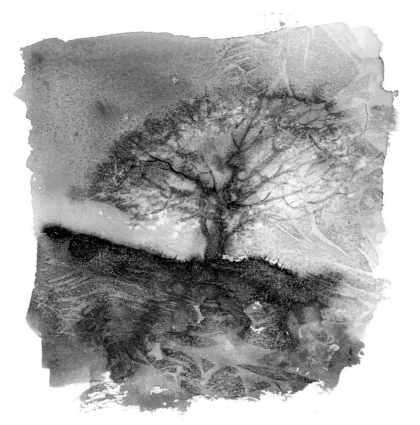

Edge values

The role of different edge values tends to be greatly underestimated, and should receive much more attention than it gets. Edge values can affect the whole mood and atmosphere of a painting. Firm, sharp shapes are graphic and powerful, so a painting built from hard edges will be loud, busy and dramatic; blurred, dreamy, amorphous shapes are more romantic, moody and distant. Whole paintings can be developed with soft, wet-into-wet, smudged edges to suggest fading light, rainy weather or hazy days. Usually, however, a painting will contain a variety of edges, some crisp, some vague and others that are broken or ragged.

All these edge values have an influence on the composition and the dynamics of a picture. Because hard lines and edges stand forward and shout for attention, a subject attracts the eye if it is kept crisp whereas a soft boundary melts away and the eye skates over it more quickly. You can weave a path around the painting by playing with these abstract qualities.

△ Hawthorn 1
12 × 12 cm (4¾ × 4¾ in)

The tree was painted while the sky was still damp to make fuzzy edges. The foreground was also put in when the upper washes were damp so that its edge has an interesting semi-hard and soft quality.

▷ Hawthorn 2
18 × 18 cm (7 × 7 in)

The crisp, dark tree trunk and lower branches are a strong contrast to the section of stark white sky behind. The hazy salmon pink streaked with clingfilm cloud wisps helps to emphasize the brightness of this focal point.

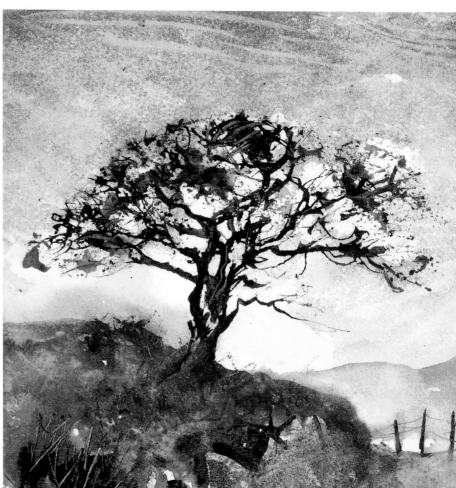

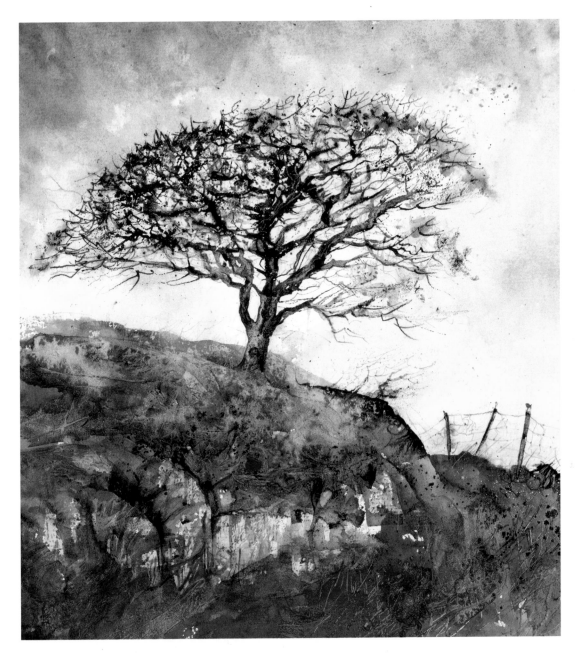

The crisp slabs of pale rock in the foreground relieve the mostly soft texture that I applied to the rest of this section. I used black watercolour pencil for the finer twigs in the tree. Used on damp paper these lines have a slightly rough, broken quality.

Explore further

- Paint at least two different versions of a similar subject. One could be painted on wet paper to create very blurred, out-of-focus areas of colour. Another example could be on a dry surface, keeping the edges sharp and maybe including some crisp line work. A third version could be built up with dry brushwork, using thick paint to create fluffy, frayed edges.

GUEST ARTIST
Shirley Trevena RI

Shirley Trevena is a well-known and very successful watercolourist. Throughout her career she has pushed the boundaries of watercolour and is now regarded as one of Britain's most experimental and innovative artists in the medium. She is a member of the Royal Institute of Painters in Water Colours.

Shirley is famous for her fabulous flower and still life watercolours. She also paints wonderfully textural landscapes, experimenting and combining materials such as collage and printmaking with watercolour. In her landscapes she often uses a palette of subtle shades that are very different to her stock in trade of vibrant colour.

The information for *Small House in the Dales* was taken from several photographs that Shirley took on holiday in Yorkshire. In her studio she did a monoprint for the base. This was made by rolling printer's ink onto a perspex sheet, placing paper onto the blotted ink and drawing with a sharp pencil point. The ink was picked up on the back of the paper to produce a reversed image. In places she pressed down with her knuckles or scraped the surface with a comb to create textures.

Judicious addition of collage to the monoprint adds realism to the semi-abstract design. Shirley stuck magazine cuttings of buildings and areas of texture or colour to the base, then drew over them in places with oil pastel and with coloured pencil to create fine lines. The picture was pulled into a cohesive whole with further drawing and painting.

△ Watercolour was painted over the water-soluble printing ink to give a soft smudgy texture. This detail also clearly shows some of the marks made in the monoprint process.

◁ In this detail pieces of collage have been blended harmoniously into the painting with a variety of added marks, including lines drawn with coloured pencil and dots and smudges of oil pastel.

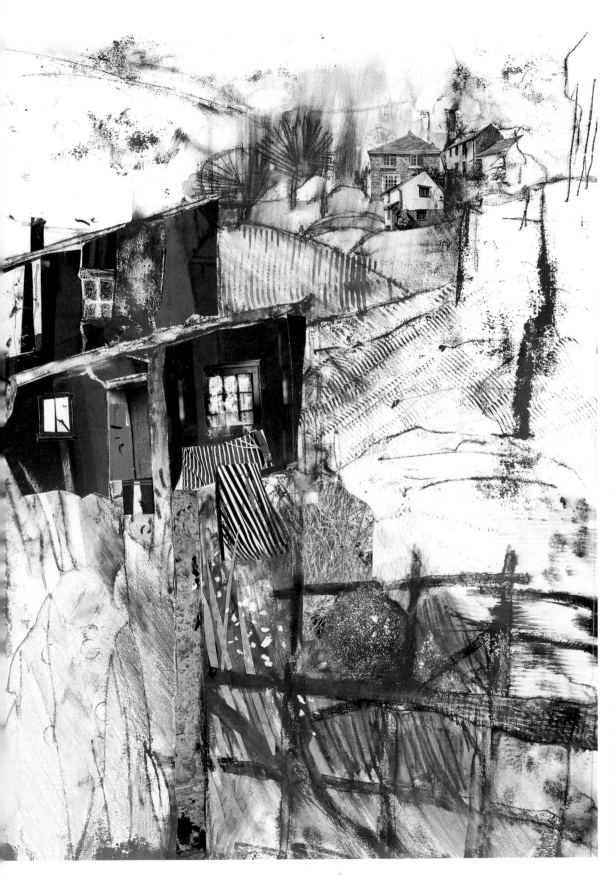

◁ Small House in the Dales
40 × 30 cm (15¾ × 11¾ in)

The complexity of the
textures and variety of
techniques employed is
balanced with a strong
composition. Vertical lines
lead the eye through the
painting then zigzag
diagonally to draw a
pathway up to the buildings
at the top.

Moving on

This is an early watercolour by my late father, John Blockley, to whom this book is dedicated. It is a moody painting, full of soft marks and subtle colour. He constantly experimented to find textures that expressed the character of his subjects and never stopped exploring new ways to express his vision in paint. Consequently, his work changed and developed throughout his life. People loved his early watercolours but he nevertheless chose to follow his instinct and moved on to discover vivid colour, new mediums and a stunning progressive style. He was an inspiration to many. I hope that by reading my book and looking at the textures in my work and that of other artists you will be encouraged to explore for yourself and move forward with your own paintings.

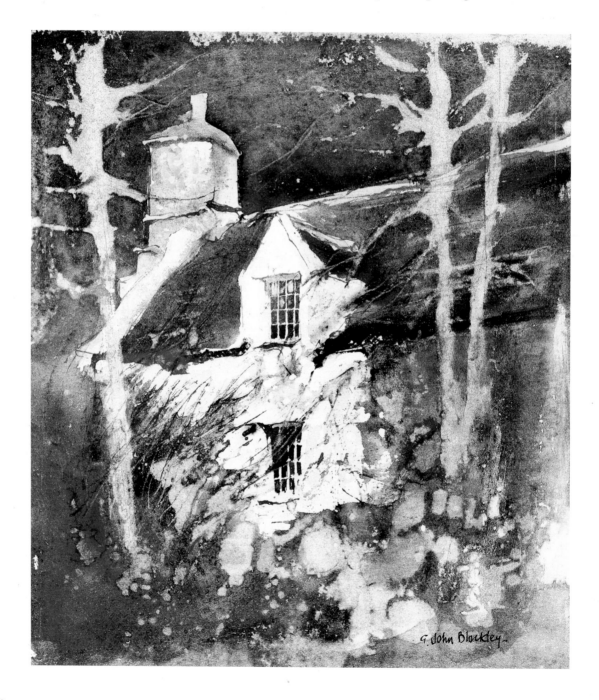

▷ **Cottage in the Woods**
John Blockley
20 × 18 cm (8 × 7 in)

Taking it further

There is a wealth of further information available for artists, particularly if you have access to the internet. Listed below are just some of the organizations or resources that you might find useful to help you to develop your painting.

ART MAGAZINES
The Artist, Caxton House, 63/65 High Street, Tenterden, Kent TN30 6BD; tel: 01580 763673
www.theartistmagazine.co.uk
Artists & Illustrators, 226 City Road, London EC1V 2TT; tel: 020 7700 8500
www.aimag.co.uk
International Artist, P. O. Box 4316, Braintree, Essex CM7 4QZ; tel: 01371 811345
www.artinthemaking.com
Leisure Painter, Caxton House, 63/65 High Street, Tenterden, Kent TN30 6BD; tel: 01580 763315
www.leisurepainter.co.uk

ART MATERIALS
Daler-Rowney Ltd, Bracknell, Berkshire RG12 8ST; tel: 01344 424621
www.daler-rowney.com
Winsor & Newton, Whitefriars Avenue, Wealdstone, Harrow, Middlesex HA3 5RH; tel: 020 8427 4343
www.winsornewton.com

ART SHOWS
Artists & Illustrators Exhibition, 226 City Road, London EC1V 2TT; tel: 020 7700 8500 (for information and venue details)
Patchings Art, Craft & Design Festival, Patchings Art Centre, Patchings Farm, Oxton Road, Calverton, Nottinghamshire NG14 6NU; tel: 0115 965 3479
www.patchingsartcentre.co.uk
Affordable Art Fair, The Affordable Art Fair Ltd, Unit 3 Heathmans Road, London SW6 4TJ; tel: 020 7371 8787

ART SOCIETIES
Federation of British Artists (including Royal Institute of Painters in Water Colours), Mall Galleries, 17 Carlton House Terrace, London SW1Y 5BD; tel: 020 7930 6844
www.mallgalleries.org.uk

Society for All Artists (SAA), P. O. Box 50, Newark, Nottinghamshire NG23 5GY; tel: 01949 844050
www.saa.co.uk

BOOKCLUBS FOR ARTISTS
Artists' Choice, P. O. Box 3, Huntingdon, Cambridgeshire PE28 0QX; tel: 01832 710201
www.artists-choice.co.uk
Painting for Pleasure, Brunel House, Newton Abbot, Devon TQ12 4BR; tel: 0870 44221223

INTERNET RESOURCES
Ann Blockley: the author's website, with details of her books, videos, exhibitions and painting courses
www.annblockley.com
Art Museum Network: the official website of the world's leading art museums
www.amn.org
Artcourses: an easy way to find part-time classes, workshops and painting holidays
www.artcourses.co.uk
The Arts Guild: on-line bookclub devoted to books on the art world
www.artsguild.co.uk
British Arts: useful on-line resource to help you to find information about all art-related matters
www.britisharts.co.uk
British Library Net: comprehensive A-Z resource including 24-hour virtual museum/gallery
www.britishlibrary.net/museums.html
Galleries: the UK's largest-circulating monthly art listings magazine, with details of exhibitions and other art services
www.artefact.co.uk
Galleryonthenet: provides member artists with gallery space on the internet
www.galleryonthenet.org.uk
Open College of the Arts: an open-access college, offering home-study courses to students worldwide
www.oca-uk.com
Painters Online: interactive art club run by The Artist's Publishing Company for amateur and professional artists
www.painters-online.com

RA Magazine: a quarterly magazine published by the Royal Academy, covering the latest developments in the arts
www.ramagazine.org.uk
WWW Virtual Library: extensive information on galleries worldwide
www.comlab.ox.ac.uk/archive/other/museums/galleries.html

VIDEOS
APV Films, 6 Alexandra Square, Chipping Norton, Oxfordshire OX7 5HL; tel: 01608 641798
www.apvfilms.com
Teaching Art, P. O. Box 50, Newark, Nottinghamshire NG23 5GY; tel: 01949 844050
www.teachingart.com

If you have enjoyed this book, why not have a look at other art instruction titles from Collins?

FURTHER READING
Bellamy, David, *Painting Wild Landscapes in Watercolour*
Blockley, Ann, *Flower Painting Through the Seasons*
Learn to Paint Country Flowers in Watercolour
Crawshaw, Alwyn, *Ultimate Painting Course*
Jennings, Simon, *Collins Artist's Colour Manual*
Collins Complete Artist's Manual
Shepherd, David, *Painting with David Shepherd*
Simmonds, Jackie, *Watercolour Innovations*
Soan, Hazel, *Gem 10-minute Watercolours*
Learn to Paint Vibrant Watercolours
Secrets of Watercolour Success
Stevens, Margaret, *The Art of Botanical Painting*
Trevena, Shirley, *Taking Risks with Watercolour*
Vibrant Watercolours
Waugh, Trevor, *Winning with Watercolour*
Whitton, Judi, *Loosen up your Watercolours*
Wilkins, David G. (General Editor), *Collins Big Book of Art*

For further information about Collins books visit our website:
www.collins.co.uk